Granite & Cedar

For Karl & Sue
Best wishes from the heart of the kingdom!

John M.

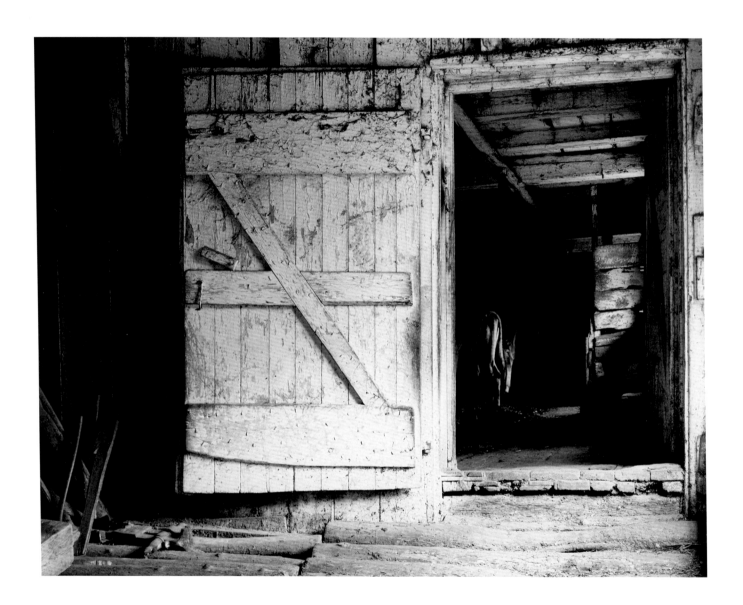

Granite & Cedar

The People and the Land of Vermont's Northeast Kingdom

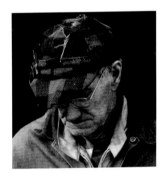

John M. Miller

with short fiction by

Howard Frank Mosher

Thistle Hill Publications · Vermont Folklife Center

Distributed by
UNIVERSITY PRESS OF NEW ENGLAND
Hanover, New Hampshire and London, England

Granite & Cedar by John M. Miller

Copyright © 2001, Vermont Folklife Center
and Thistle Hill Publications

Photographs copyright © 2001, John M. Miller

"Second Sight," copyright © 2001,
Howard Frank Mosher

Design:
The Laughing Bear Associates
Montpelier, Vermont

Printing:
The Stinehour Press
Lunenburg, Vermont

ISBN 0-9705511-1-8

Publication of this book was made possible, in part,
by a grant from the Vermont Arts Council.

THE VERMONT FOLKLIFE CENTER is a cultural heritage organization
that preserves and presents the traditional arts and folkways of
Vermont and surrounding regions. It is located at 3 Court Street,
Middlebury, Vermont 05753.

THISTLE HILL PUBLICATIONS is a Vermont publishing company
that specializes in art and photography books and works about and
of interest to the people of Northern New England. Its address is
Post Office Box 307, North Pomfret, Vermont 05053.

Distributed by University Press of New England,
Hanover, NH and London, England

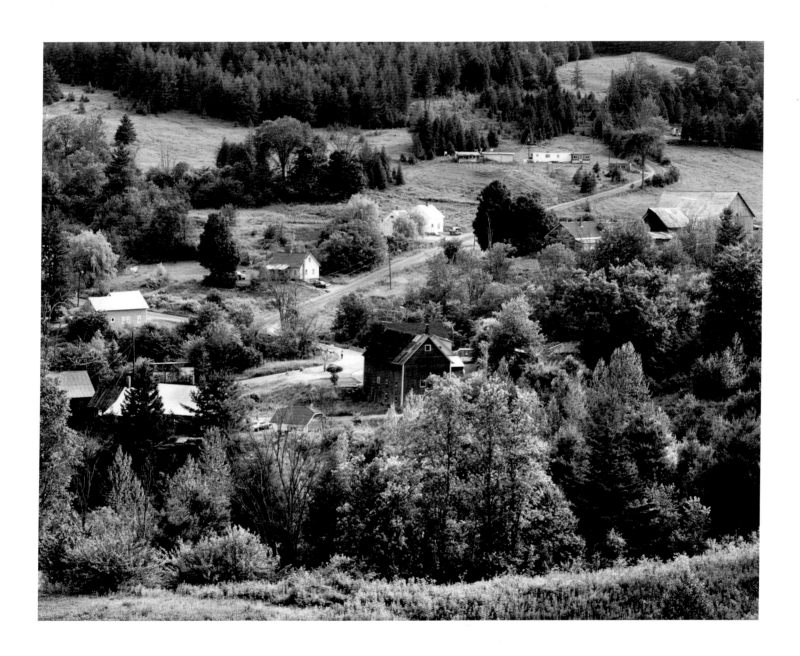

INTRODUCTION

It was not until November, 1949, that U.S. Senator George Aiken first identified the northeastern corner of Vermont as the Northeast Kingdom, thus giving name to a unique region—remote, wild, and peopled by hardy, flinty, and independent individuals who were molded both by their environment and by the ever-prevailing wind of tradition. More than half a century later, the Northeast Kingdom remains a place apart: in some cases, a last bastion of a crumbling way of life still fighting change, but in others it embraces new ways, new generations, new creativity. Change never comes gracefully in the Kingdom, and many of its natives' long-held, deeply ingrained attitudes and values often conflict with ideas brought by newcomers, be they French Canadians from the north, urban folk from the cities, or inhabitants looking for a better way of life.

At first glance, *Granite & Cedar* may seem somewhat of a departure for the Vermont Folklife Center, which has always based its exploration of culture and heritage on oral interviews. We look at it, however, as an attempt to use another lens, so to speak, to view many of the issues that most concern the Folklife Center. The focus, as defined visually by John M. Miller's stark black-and-white photography supplemented by Howard Frank Mosher's fiction,

remains centered on people, place, tradition, and change, enriching and complementing the Center's work. We see Aunt Jane's "everyday brooch" (a safety pin) holding together a man's jacket that no longer zips, and above it the weathered face of a logger who has known hard labor in the out-of-doors. The onlooker somehow feels that his face mirrors his inner soul. The "Salada Tea" sign on the window of the deserted general store and post office of Hubbellville is reiterated in John Miller's photograph of the Davis General Store with a group of men who are obviously engaged in what was known in West Danville as "store court."

Howard Mosher takes his lead from George Aiken and writes of Kingdom County, Kingdom Common, Kingdom Mountain, and Kingdom River. As with John Miller's photographs, we feel a real sense of place — a place well trod by the generations of men and women who lived off the land and were shaped by an unforgiving environment. But a changing place. While Jane Hubbell is relentlessly old-fashioned and concerned with passing on traditions, she prefers second homes to no homes, new life to a decaying hamlet, and the possibilities the future high road would allow. She is eminently practical.

The decay of buildings, the encroachment of time and nature upon these structures, the residents themselves, all suggest the passage of time, as well as a tenacious rootedness in place. But often creativity grows out of the landscape, as evidenced by the many "barnyard" artists who lived and worked here. Often, they painted or carved on cedar or on granite. Those materials are apt symbols for the Northeast Kingdom, because they represent both resilience and the hardness of life. A wood that doesn't rot, and that is resistant to insects, cedar is also easy to shape. As such it is preferred for fence posts as well as for whittling — like the cedar fans crafted by loggers during lumber camp days or the carved faces sometimes seen on cedar fence posts. Likewise, when fields are no longer tended, plowed, and harrowed, or kept down through grazing, the wirebrush and brambles, followed by the cedars, poplar, and birch, begin to encroach on the man-made order. As the brush and cedar overwhelm the fields, so the old ways and traditions are eroded.

Outcroppings of granite are found everywhere in the Northeast Kingdom. Indeed, they were the bane of farmers' existence, for to break a scythe or a piece of farm machinery was a major catastrophe. Many hours were spent clearing away stones and rubble which went into stone walls and cairns. The granite has also served as symbolic of the people themselves and their never-ending perseverance.

Granite & Cedar documents a time of critical change in the Northeast Kingdom. Most of John Miller's photographs were taken between 1971 and 1976, and Howard Mosher's piece is set in 1965. Before then, the Northeast Kingdom was a world unto itself. But the coming of the interstate highway made the Kingdom more accessible. It then became possible to have a second home there and be able to reach it without difficulty. Likewise, local residents could come and go with relative ease. Patterns of living began to change. No longer was the family farm a viable entity. New technology and environmental concerns were altering the timber industry. Computer technology enabled urban dwellers to take up residence far from city centers.

Miller, a native of the Northeast Kingdom, has put together a photographic treatise that not only portrays a sense of rural traditions and texture of life, but one that underscores a sense of loss. Mosher reflects that loss, too, but reaffirms new patterns growing out of the old. Old traditions die hard. But as the cultural environment changes, so do the people. Here, Howard Mosher and John Miller present us with remarkable testimony in photographs and words that together endow us with better understanding of the land and the people of the Northeast Kingdom as it faced the major changes of the late twentieth century.

Jane C. Beck
Vermont Folklife Center

Granite & Cedar

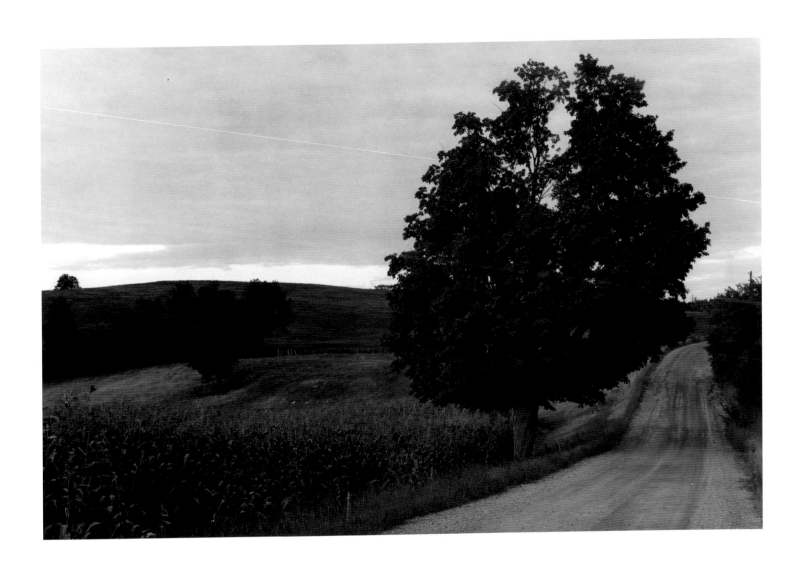

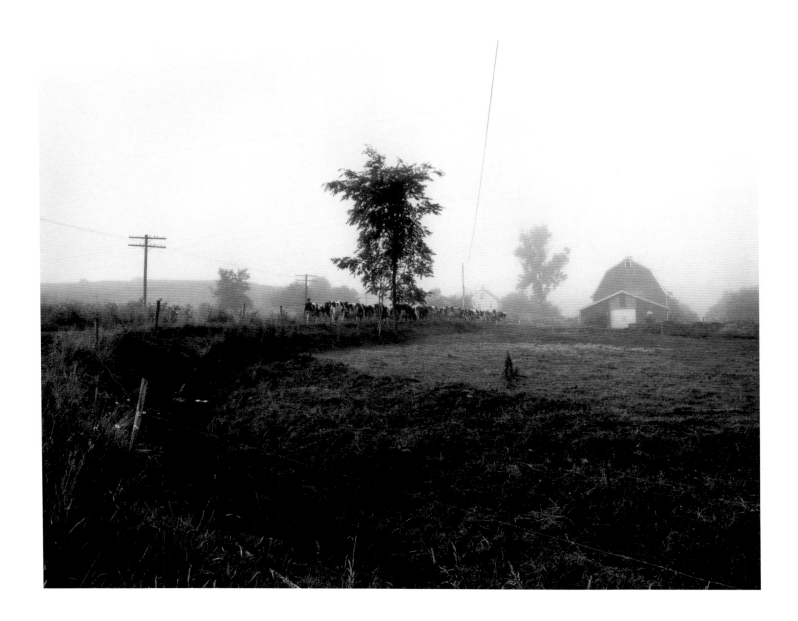

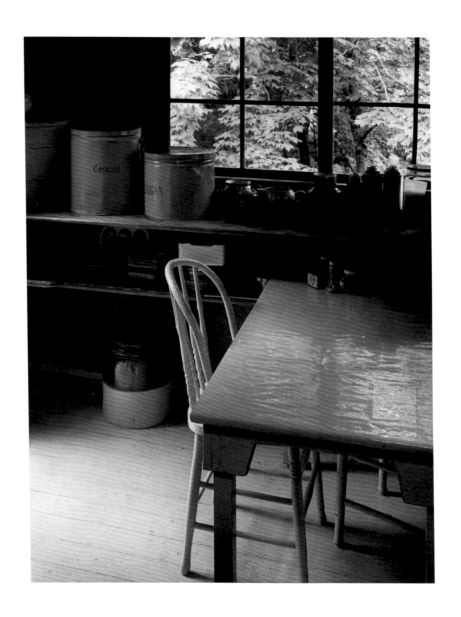

SECOND SIGHT

Howard Frank Mosher

THE HIGHROAD

MY GREAT-AUNT JANE HUBBELL WAS BORN IN 1887, AND LIVED all her life on Kingdom Mountain. Throughout the remote border country of northeastern Vermont, she had the reputation of being relentlessly old-fashioned. Jane wore long black dresses made from the homespun wool of her own sheep. She farmed with oxen. She baked her own bread and churned her own butter. Even Jane's way of expressing herself was old-fashioned. Though she was well-educated by the standards of the time and place, she delighted in using the antique phrases of her Scottish ancestors. For "certain" she often said "determined." As in, "I'm not entirely determined what to do with you, Rob Hubbell. But I will not abide slothfulness in any nephew of mine." "Abide," in the sense of "to tolerate," was another of Jane's favorite expressions. And she often used the term "vexed" to denote a frame of mind just shy of anger. "Rob, you're late for chores again. Sometimes you vex me beyond endurance." In those days, it seemed to me that my Great-Aunt Jane was vexed with me far more often than not.

The summer I turned fifteen, I was secretly relieved when a new interstate highway from Boston to Montreal was slated to pass through Kingdom County. For all of its drawbacks, chief among them that it would connect us residents of the Kingdom to a larger world we had little trust in and less use for, I-91 would at least give my great-aunt something besides me to be vexed with. Characteristically enough, Jane refused to refer to the superhighway as anything other than the "Highroad." Maybe this was one more of her beloved anachronisms. Or maybe she thought of the interstate as the Highroad because it would run mainly through elevated terrain, avoiding the river valleys where the villages and larger farms lay. Then again, Jane may have wished to distinguish I-91 from the tangled network of country lanes, logging traces, and narrow blacktop roads that linked our small farms and upland hamlets one to another in the roundabout way of those years. There would be nothing circuitous about the interstate, however. It would pass straight through Jane's farm. Worse yet, it would cut off, from the rest of the Kingdom Mountain cemetery, the plot where Jane's parents were buried. And there was no doubt in my mind, or in anyone else's, that this was a vexation that Jane Hubbell would not abide.

We supposed that, given her legendary stubbornness, not to mention her fierce loyalty to her family, both living and dead, Jane would sue the state and represent herself; or camp in the graveyard and refuse to budge, even in the path of the state's behemoth yellow earth-movers; then, when the state exercised its ultimate right of eminent domain and had her removed by the law, assuming they could find a local lawman to do it, she would no doubt refuse, on principle, to accept a penny of compensation.

What we had forgotten was that Miss Jane Hubbell of Kingdom Mountain was as unpredictable as she was stubborn. At the public hearing for I-91 at the Kingdom Common town hall early in November, she listened to other farmers whose land would be confiscated inveigh against change in general and the new highway in particular. She listened to the chief highway engineer for the State of Vermont present his plans and maps and assure landowners

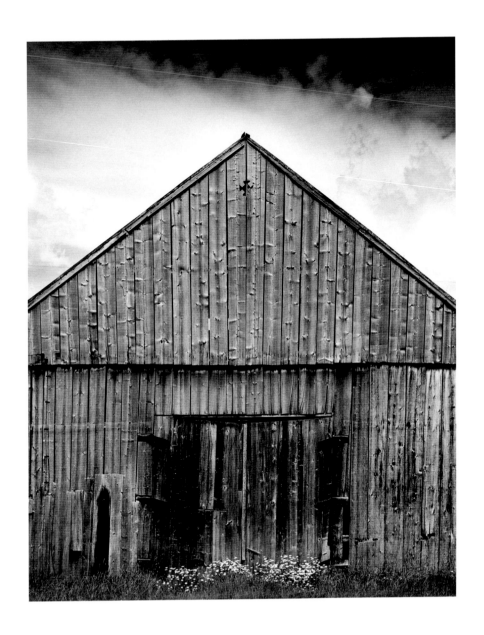

that every effort had been made to route the interstate through the higher, less valuable terrain. When my father stood up and pointed out, reasonably enough, that we hill farmers valued our high mowings and lofty mountain meadows as much as valley farmers valued their land, she merely pursed her lips. Jane knew, of course, that protesting would do us no good at all. Even as we sat assembled in our little hall, the interstate was unspooling north from Boston and south from Montreal with something of the inexorableness of the glacier that had carved out our hills and valleys ten thousand years ago — and with infinitely greater speed. Do what we might, it would arrive in the spring. Our best hope now, our last hope, really, was that my regal great-aunt, who for more than half a century had held sway over Kingdom Mountain like a Russian empress, and whose words at our annual town meeting still caused grown men who had gone to school to her as boys to quail in their boots, would speak for us. Wasn't Jane widely believed to have second sight, like our Hubbell ancestors from the Hebrides? Perhaps she would prophesy some magnificent catastrophe if the state went ahead with the Highroad!

At last Jane rose. She stepped into the sloping wooden aisle of the hall where, sixty years ago, she had delivered her high school valedictory — a scathing denunciation of small-town complacency and provincialism that reportedly shocked the entire room into a prolonged stunned silence. But instead of the expected prophecy or jeremiad against progress, she said only, in her usual harsh, not unhumorous manner, "I can plainly see that in this instance we shall have to render unto Caesar what's his."

Well. This was not what we had hoped for. And while the slight and bespectacled young highway engineer probably did not much relish being compared to a Roman dictator, he, too, had undoubtedly heard in advance about the formidable Jane Hubbell. So it was with palpable relief that he said, "We appreciate your willingness to understand our situation, Miss Hubbell. Particularly in your case, where this is such a personal matter. Of course we, I mean we the state, will take care of the — transfer."

"You the state will take care of no such thing," Jane said, her voice as harsh as a blue jay's call, and no longer humorous at all. "The Hubbells have always taken care of their own. We shall take care of our own now."

"Miss Hubbell, we'll gladly—"

"Hear me well, Caesar," my great-aunt said. "If I spy you or any of your legions near that burying place before I move those graves myself, I'll defend what's mine by whatever means are necessary."

"Please! There's no need to threaten anyone."

"I've never threatened anyone in my life and I'm not threatening anyone now. If a distempered animal ventures onto my place, I don't threaten it. I destroy it with no more thought than brewing a cup of tea. If I discover you or your minions near those gravesites before I have a chance to move them, I'll put you down like a rabid fox."

I do not know how such an unambiguous declaration might have been greeted elsewhere. Maybe with applause. Or maybe with silence, like the silence after Jane's long-ago graduation speech. In Kingdom County in 1965, Jane's announcement was met by solemn nods of satisfaction. This was something like what we had hoped to hear her say; and now that she had spoken, we all felt somehow better about the interstate. The chief engineer, for his part, said nothing more.

But I was wondering. How, at seventy-eight, did my great-aunt propose to exhume and move those two graves high on Kingdom Mountain? As I walked out of the town hall into the freezing November night at her side, the answer came to me.

Never, in all of my fifteen years, had I dreaded anything half so much.

• �char

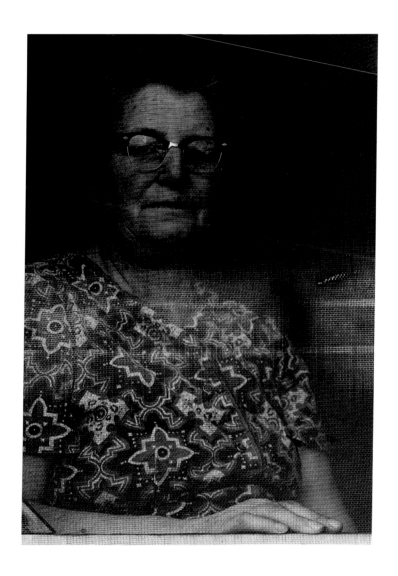

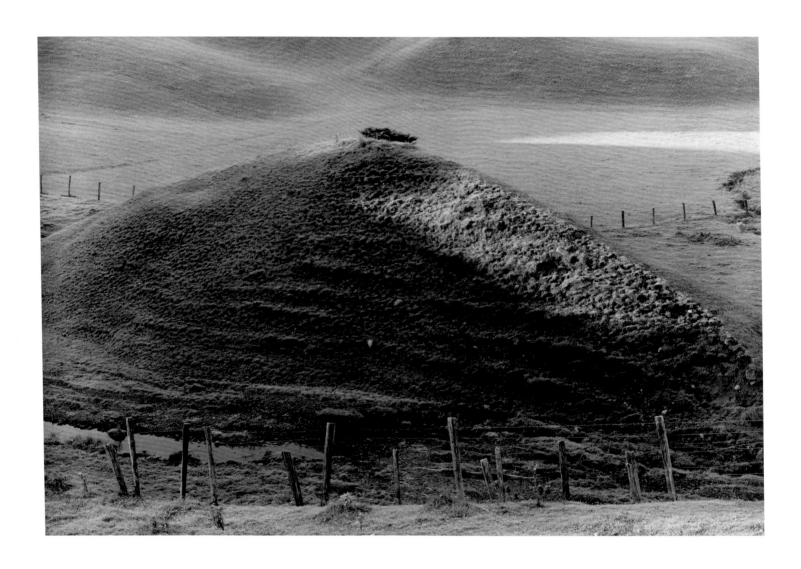

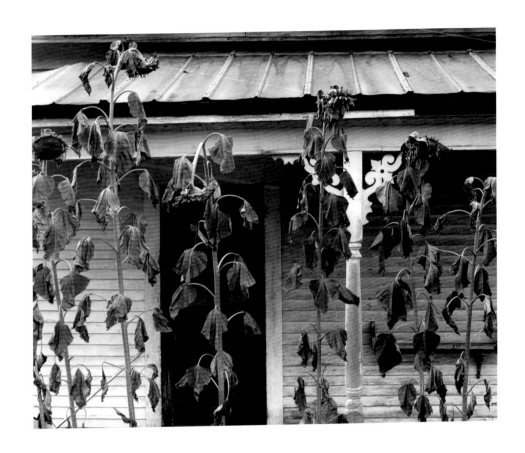

FALSE SPRING

"EVERYONE KNOWS WHAT INDIAN SUMMER IS, ROB. ABOUT once in every generation, Indian Summer turns into false spring. This is false spring." I had been out of sorts—or, as my great-aunt had put it, "at sixes and sevens"—since arriving at the Home Place for morning chores an hour ago and seeing Jane's yoke of oxen hitched to the stoneboat in her dooryard. On the flat bed of the boat were two long-handled spades, an iron bar, a coil of stout rope, and a wicker basket containing our lunch. Though the temperature was already well over 70 degrees—a nearly unheard of high in northern Vermont for late November—a chill ran through me. Grave-moving day had arrived.

My aunt clicked to the oxen and we started up the lane behind the thumping stoneboat. "False spring," Jane continued, "is a time when nature itself is baffled. The trees begin to leaf out, the grass turns green again, spring bulbs come up and blossom. Look down in the glen, Rob. Even the geese are fooled."

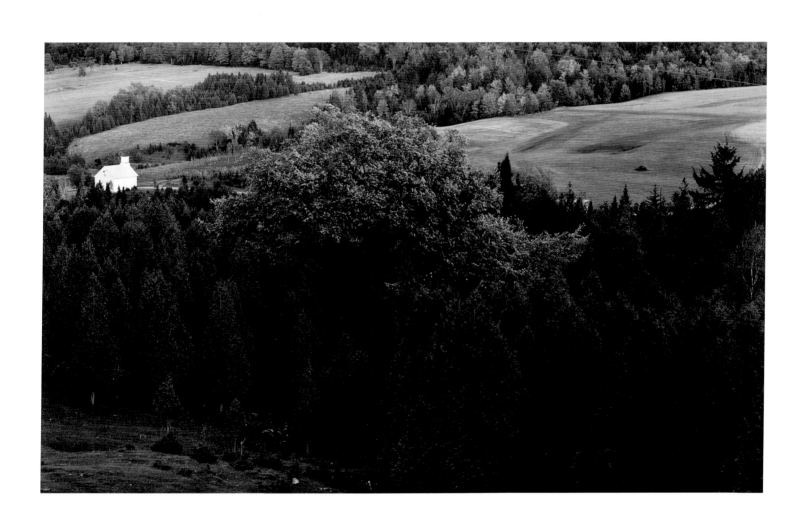

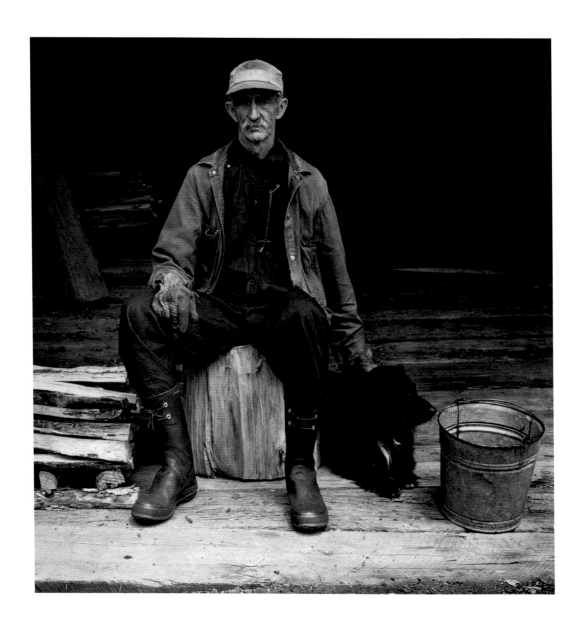

She pointed back down the mountain, past the weathered Home Place, into the valley below. A flock of fifty or sixty snow geese, their white wings etched in inky black, were flying north up the river. Barking like an excited pack of hunting dogs, they swerved up the mountain toward us and landed in Jane's cut corn field.

"Let me run home for my shotgun," I pleaded. "It won't take twenty minutes." On any other day Jane would have let me fetch my gun and shoot one — just one — goose. Not today. "We just have sufficient time as it is, Rob. If false spring holds, the geese will still be here for you to hector tomorrow."

As we continued up the lane, I felt like the detained wedding guest in "The Rime of the Ancient Mariner," which Jane had hectored me into memorizing a few years ago. I felt as if I were all but exploding of frustration — not to attend a wedding, but to hunt those wild white geese. Yet my aunt, for all her idiosyncrasies, was no glittering-eyed lunatic, but a woman of great purposefulness, who knew exactly what she was doing and making me do and exactly why. As usual, she wore a long dark dress, high rubber barn boots and, despite the warm weather, her red wool hunting jacket, fastened at the top, where it was missing a button, with an oversized safety pin she called her "everyday brooch." Her abundant hair, pinned up on her head, was still very dark. And she walked as straight and tall as any woman in Kingdom County, and briskly, too, so that I had to hurry to keep pace with her and the oxen.

The lane hooked up the mountainside between Jane's sheep pasturage and the corn stubble where the snow geese were grazing. Ahead was the original homestead of the first Hubbell to come to Kingdom Mountain, familiarly known to his descendants as old Seth. Here, in 1775, old Seth had thrown up a one-room log house in the wilderness, where he had lived for a few years before building the Home Place. Under the poplars marking the site of the original homestead, a lone daffodil was blooming where I had never seen a daffodil before. For all I knew, the flower had been dormant for nearly two centuries, forced into

blossom at last by false spring. Overhead, the poplars had put out new catkins, fuzzy and gray-green. They scented the air with their warm resin, as they did each May when true spring finally reached Kingdom County.

We continued along the lane behind the oxen, now dipping down the west ridge toward the cedar bog between the foot of the mountain and the Kingdom River. We passed the cellar holes and barn foundations of the long-abandoned Emerson place, Robinson place, Patrick place. In the hedgerows, shadbushes were blossoming five months ahead of their time. Buttercups bloomed in the disused fields between the old farmsteads.

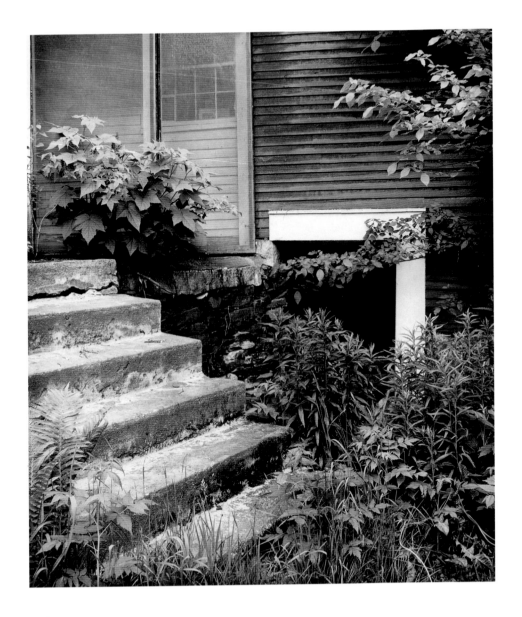

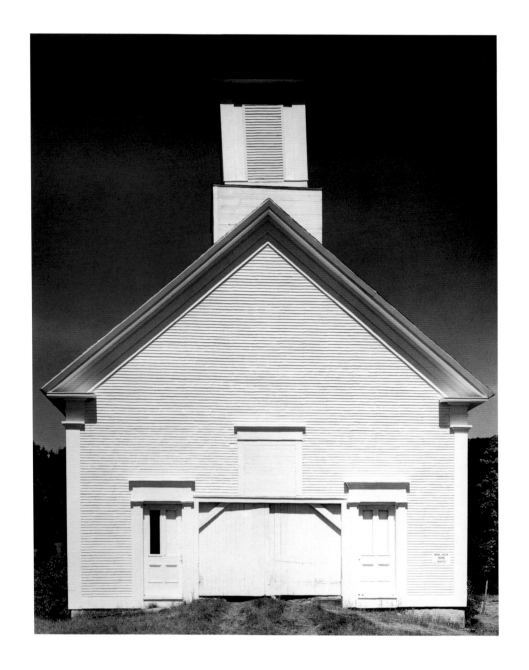

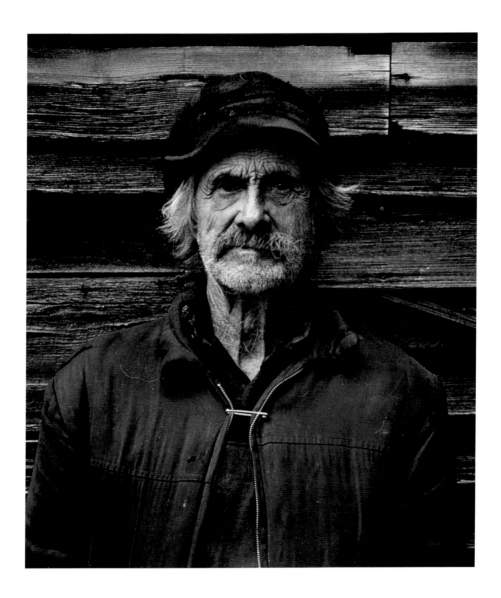

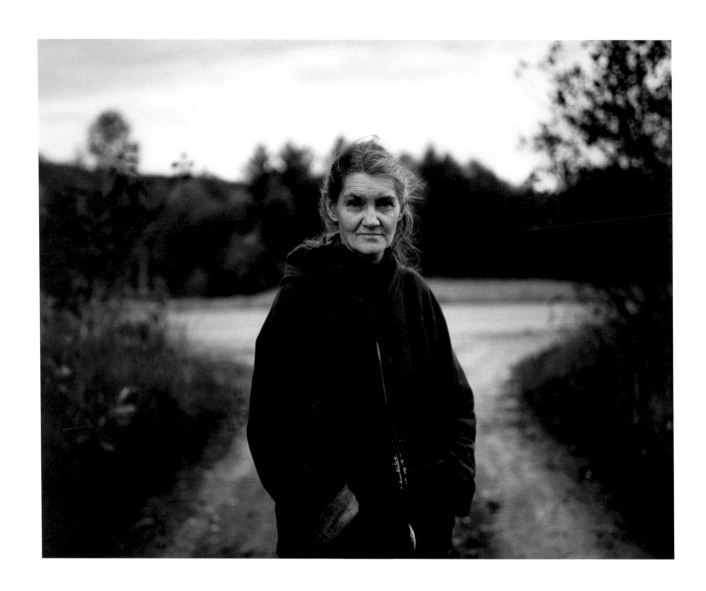

THE CEDAR BOG

HALF A MILE WEST OF THE HOME PLACE, THE LANE RAN through the northeast edge of a cedar bog. In a spongy region more water than dry land, we crossed an ancient plank bridge over the west-running brook off Kingdom Mountain. Downstream from the bridge, the character of the mountain stream altered dramatically. The quick brook became a dark, creeping flow, winding under the gloomy cedars and losing itself a dozen times in slangs and beaver backwaters before reaching the Kingdom River. The bog water was tea-colored. The backs and sides of the trout that lived here were dark as well. In the winter, we cut cedar fence posts and rails in the bog and skidded them out over the ice with Jane's oxen. The biggest bucks in Kingdom County bedded down in the heart of the bog by day, emerging to feed in the abandoned fields on the mountain only after dark. To me, the bog was a forbidding place. There were stories of unexplained disappearances and a *loup-garou* that had dwelt here since time out of mind—a monstrous werewolf that devoured wayfarers overtaken by darkness!

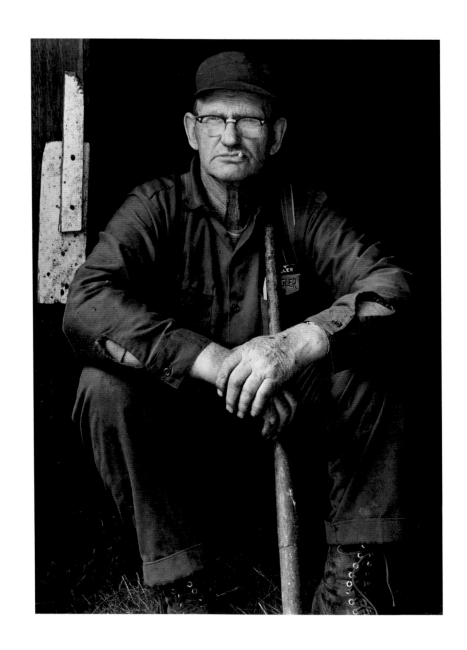

"This was Robert Burns Hubbell's favorite place in the Kingdom," Jane said as we stood on the bridge and looked out over the cedar bog. "My wild younger brother was as much at home here as the moose and bobcats."

"What did your brother do that was so wild?"

Jane smiled. "Oh, he took a few trout and deer out of season. Robert Burns Hubbell was a very neat hand with a long cane fishing pole, Rob. And with a jacklight and a rifle, too. During Temperance Time, he ran a little Quebec whiskey over the line to Hubbellville. From there he'd cut down the lane to this bridge, drive across, then pick up the planks and hide them so the revenuers couldn't follow him." Jane chuckled. "More than one carful of government men in hot pursuit of Robert Burns Hubbell wound up in the drink."

"Jane? Do people really disappear in the bog?"

She hesitated for a moment. Then she said, "I've known just one who did. A girl—a young woman, actually. It was early winter and the ice under the snow was uncertain. It was supposed that she drowned but no one really knew. They never found the body." My aunt sighed. "Hand me that iron bar from the stoneboat, Rob. Thinking of Robert Burns Hubbell and the revenuers reminded me. We need to borrow a bridge plank ourselves."

Jane inserted the end of the bar under one of the twelve-foot-long planks over the stream and pried it up. The old wood was damp and the square-headed nails pulled out easily. She pried up the middle and far end of the plank, and together we slid it onto the stoneboat—I hated to think what for.

As we emerged from the cedars into a scrub field where the lane joined the faint track known as the old Canada Post Road, Jane pointed at the top of a lone tamarack tree on the edge of the cedars. The tamarack had turned a pale gold for the fall, and on its topmost spire sat a great horned owl. The owl's ear tufts stood up like a lynx's. Beneath the tree was a barberry bush with red berries as bright as drops of blood. As we watched the owl, it tilted its head forward. Abruptly, it dived, talons extended. A snowshoe hare

turned white for the winter bounded out from beneath the bush. It screamed once, then hung limp as a white cloth as the owl silently carried it out of sight into the cedar bog.

Jane bent over and picked up a white tuft of hair near the barberry. "Ordinarily at this time of year, Monsieur Lapin would have been camouflaged by a foot of snow. The owl never would have spied him."

"Bad luck for the rabbit," I said.

"Good luck for the owl," Jane said. "Gee up, steers."

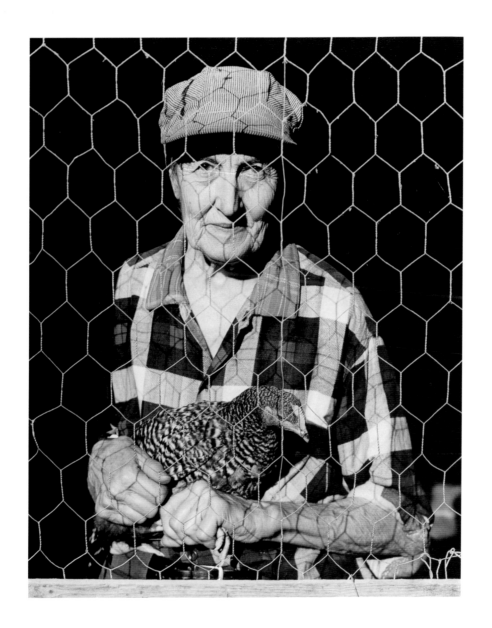

FRENCH CANADIANS

"WHY DID YOU CALL THE RABBIT MONSIEUR LAPIN?" I ASKED as we headed up the mountain on the Canada Post Road under a bluebird-blue sky.

"That's what our neighbors the Thibeaus always called the rabbits they snared. For the first few years after coming here from French Canada, Rob, the Thibeaus subsisted on rabbits. Rabbits and partridges."

She pointed up the mountainside a few hundred yards at a shallow cave where I sometimes hunted for arrowheads. "That's where they wintered over the first year."

"They spent the winter in a cave?"

"With a cow and a logging horse and a few chickens and five children, if you can imagine such a thing. Pamphille Thibeau worked in the woods, cutting logs for my grandfather's sawmill. Oh, they lived a hard-scrabble life, Rob. I was keeping the Kingdom Mountain school at the time. On the first day of school, all five of the Thibeau children showed up at the schoolhouse knowing not a word of English between them. But they turned out to be the brightest scholars I ever taught. Manon, the oldest girl, was just two years younger than I. She and I became best chums."

The Post Road wound up the mountainside, past the Thibeaus' cave. The opening ran back into the cliff about fifteen feet. In fact, it was less a cave than a shelter roofed by a natural overhang. I could not imagine anyone spending a winter here.

"Why would anyone live in a cave?"

"For the same reason Seth Hubbell lived in a log room no larger than my kitchen. To be independent and work for himself. After a few years, Pamphille bought a peddler's wagon. He traveled from farm to farm along the border selling household wares. Manon used to go along to translate for him. But the Thibeaus were always regarded as different by some people. They spoke a different language, their main holiday was New Year's rather than Christmas, and they said their prayers on a string of beads. One night soon after they shifted here from Canada, some villagers paraded up the mountain in white sheets and burned a cross in front of the cave."

"Like the KKK? The KKK in Vermont?"

"Exactly. They threatened to burn the Thibeaus out — though I don't know how they proposed to burn a cave. My chum Manon, who was as plucky as she was smart, ran cross-lots for our place, and my father rode up here and confronted the rabble."

"With his deer rifle?" I said hopefully.

Jane shook her head. "My father didn't need a rifle, Rob. He just reined in his horse and ordered them to leave the mountain immediately and not return. Then for good measure he named them all by name, sheets or no."

"How could he do that?"

"He knew well enough who the local Klan instigators were. From there it was an easy matter to surmise the names of the village riffraff who would follow them."

"So what happened to the Thibeaus? After Pamphille became a peddler?"

"Oh, they hung on for a time. But two of the children perished in the great influenza epidemic of 1918, another boy was lost in the war, yet another died in a lumbering mishap. Then Pamphille and his wife died. Eventually, the mountain claimed them all."

•➷

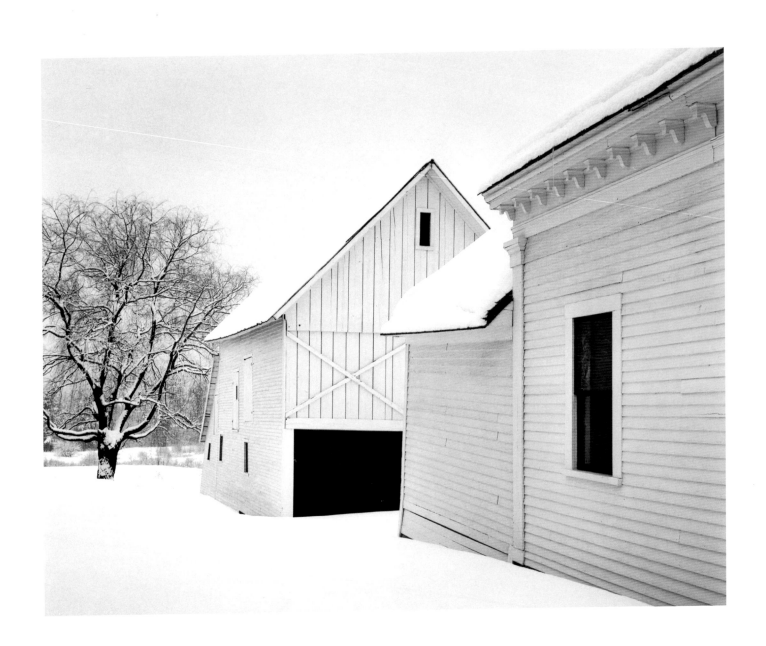

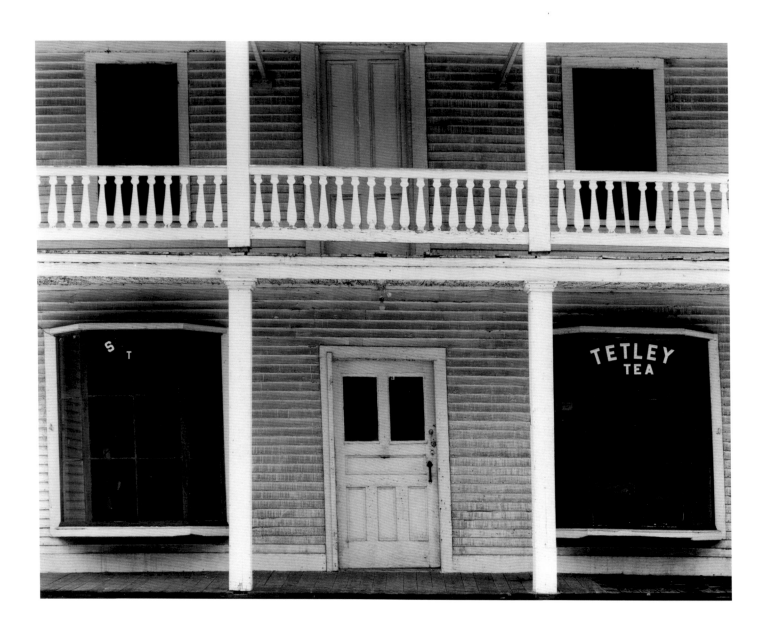

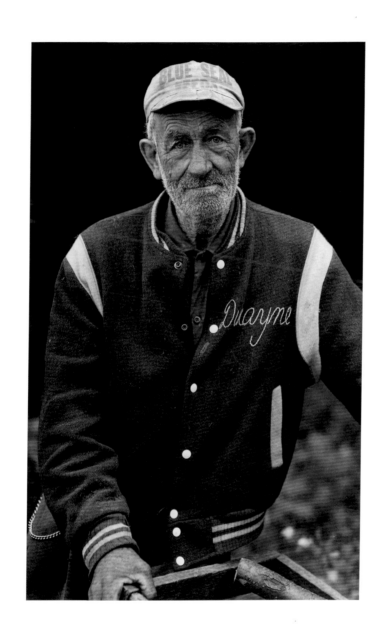

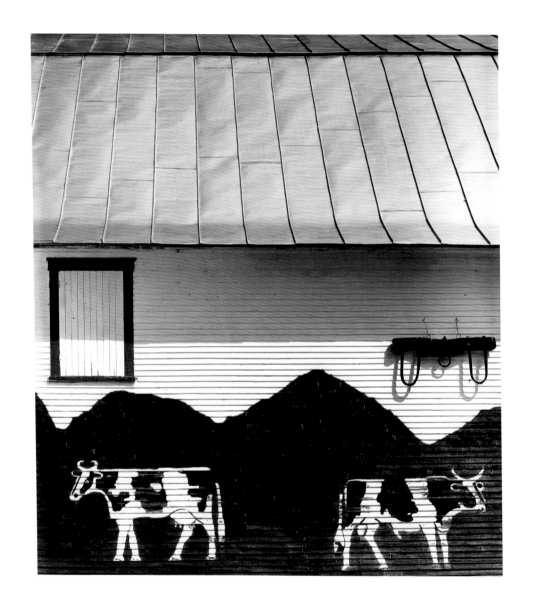

44

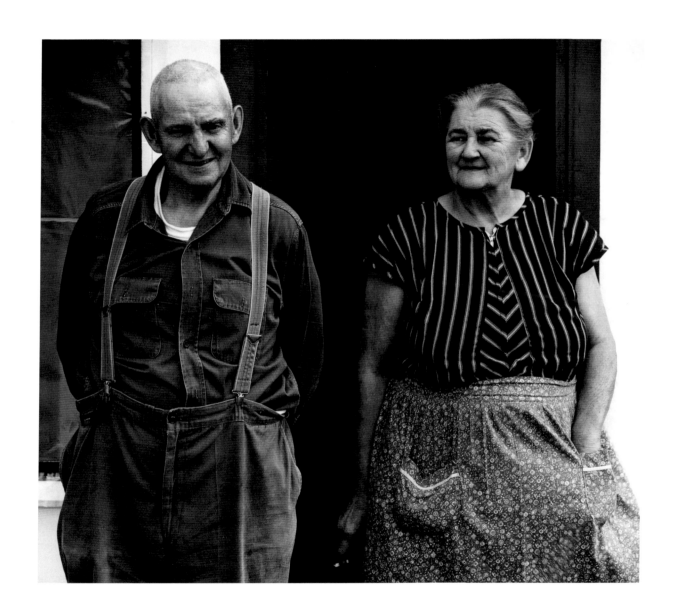

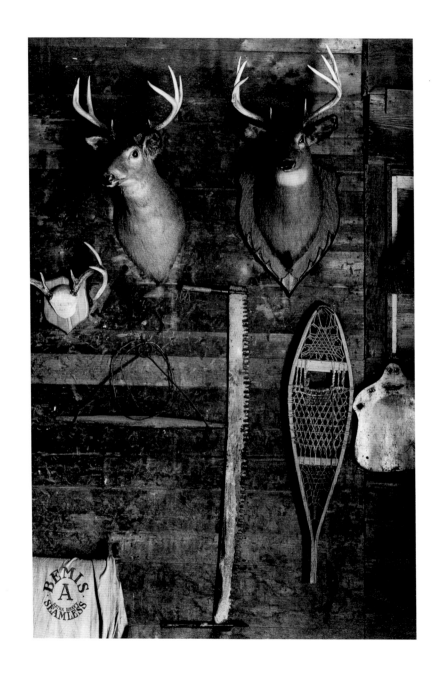

HUBBELLVILLE

"SALADA TEA." The black letters painted on the inside of the window still stood out sharp and clear. Below them, like an afterthought, were the words: "Hubbellville General Store and U. S. Post Office."

Jane and I stood on the listing store porch in the deserted hamlet. Cupping our hands around our eyes to cut down the reflection, we peered inside at the empty shelves. Set into the wall behind the counter were forty wooden cubbyholes where forty Kingdom Mountain families had once received mail. But Hubbellville had been tenantless now for more than twenty years. The store had not been a working store for longer still. The five or six houses still standing in the deserted hamlet were overrun with bittersweet and wild grape vines. In the spring, before the earthmovers arrived, they would be burned to the ground.

"When I was a young girl, Rob, I came here every Saturday morning to pick up 'The Farmer's Weekly Companion.' Once a week the 'Companion' ran pirated installments from Charles Dickens' novels, and the line of people waiting for the next installment often stretched all the way out the door and down to the street."

Across the Canada Post Road from the store was the one-room school where Jane had taught for forty years. Next to the school was the Hubbellville church. The steeple had blown off in the Hurricane of '38, and lay rotting in a patch of wild raspberries like the fallen turret of a cursed castle in a fairytale. It was said that the steeple bell, long since sold for scrap iron, still sometimes tolled to lead lost hunters out of the cedar bog.

"Aunt? Where did these people go? Did they all die in the flu epidemic?"

"No, though a good half of them did. Some moved out west, where the farming was better. The more ambitious young people went to the cities. As for the old folks and the rest, they went where I and thou must now go if we're to accomplish our day's work."

With silent eloquence, she pointed at the cemetery on the ridge above us. "Walk on, gentlemen," she said to the oxen.

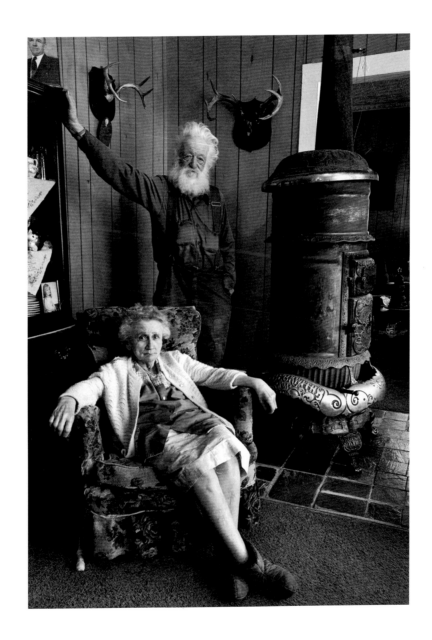

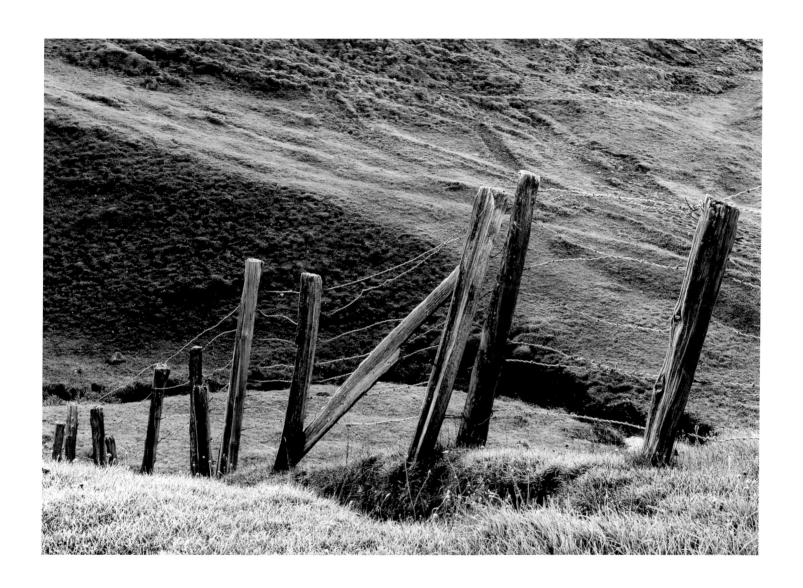

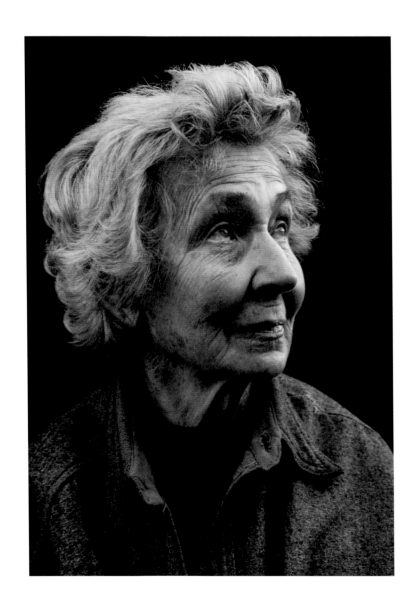

GRANITE AND CEDAR

LIKE MANY ANOTHER NORTHERN NEW ENGLAND CEMETERY, the Kingdom Mountain graveyard enjoyed the best view in the township. From here on a clear day you could look west over a one-hundred-mile prospect of the Green Mountains, stretching from Mt. Mansfield in the south to the tall Canadian peaks in the north. Off to the southeast, the Presidential Range of the White Mountains loomed larger still.

The graveyard, with its antebellum iron picket fence, contained no more than one hundred and fifty stones. None was prepossessing. Just gray granite markers, two to three feet tall, as unadorned as the lives of the people whose final resting places they marked. The names were Emerson, Robinson, Patrick, Hubbell. Through the middle of the cemetery ran a row of mature sugar maples, budding out again in the false spring. Each April, Jane unsentimentally tapped the cemetery maples. In the northwest corner of the graveyard grew several snow apple trees, whose pink-streaked fruit she gathered in September for cider. Nearby stood an elm with a swinging oriole's nest. Two new graves, which Jane had hired dug the previous week, lay waiting in the Hubbell plot near the maples. A pair of robins that should have flown south a month ago searched for worms on the fresh mounds of earth beside the graves.

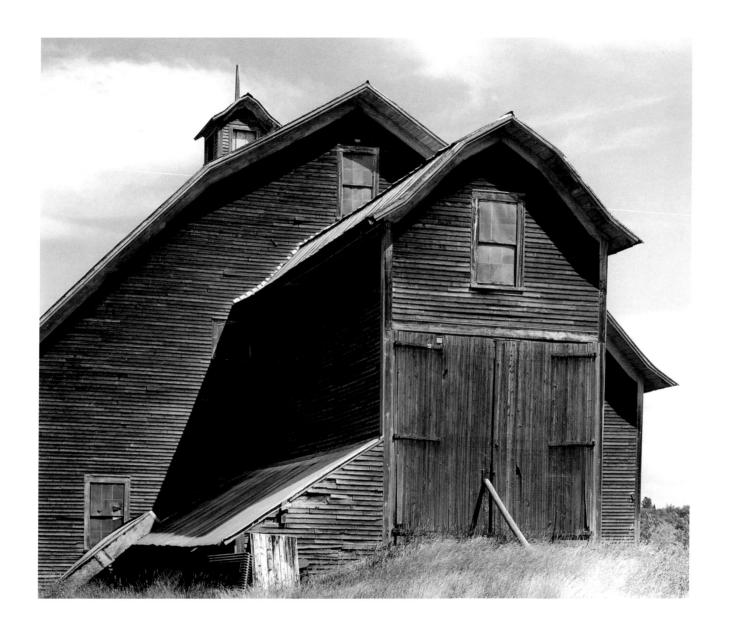

Just across the road from the Kingdom Mountain cemetery, directly in the right-of-way of the interstate, was the Paupers' Field. Here Jane's parents were buried beneath two plain granite markers. Otherwise, the Paupers' Field was a place of cedar. It was enclosed with cedar rails, some with the bark still attached. The cedar-pole gate was hinged to upright cedar fence posts. Most of the grave markers, too, were made of cedar. There were about thirty in all. Some of the crude wooden tablets had fallen over into the high grass. Long neglected, they marked the graves of the mountain's outcasts and unknowns.

"Robert Hubbell, 1852-1928." It was strange to see my own name on my great-grandfather's stone. Below his dates was the word "Father." Below that, a Masonic emblem of a compass and trowel. Beside Robert's stone was his wife's: "Addie Wright Hubbell, 1855-1920. Mother." I knew better than to ask. But I was determined, before this day was out, to learn why Jane's parents, from the oldest family on Kingdom Mountain, and one of the most distinguished, had been buried in the Paupers' Field instead of the cemetery proper.

While Jane watered the oxen at the brook, I walked through the Paupers' Field looking at the inscriptions on the cedar markers. "Unknown Died on the River." And, on a fallen tablet, carved very crudely, "A Canuck Lumberjack. Died Fightin." Beneath Died Fightin's marker a woodchuck had tunneled a hole. Nearby was the Thibeau plot. The graves of the children were designated by four lozenge-shaped wooden markers no larger than bread boards. But Jane had said there were five children and the mountain had claimed them all.

The sight of my aunt approaching took my mind off the missing marker. She handed me a shovel and walked over to her parents' grave. "This won't be nearly as bad as you think, Rob. Look upon it as just one more job of work on the mountain."

One more job of work on the mountain! Only my fear of my own cowardice kept me from dropping the shovel and racing back down the Post Road to hide in the cedar bog for the rest of the day.

"Maybe your folks wouldn't care to be moved back across the road with the others," I said desperately.

"They're past all earthly cares now," Jane said. "They should be with their relatives and neighbors."

She had already started to dig, working methodically and without haste, like a woman spading up her kitchen garden for fall. But this was no kitchen garden. And as I began digging, with my heart beating so fast I thought I could hear it, I could not shake the notion that with each new shovelful I might unearth a skull, a bony hand, or a jutting white rib.

Unlike the hard-packed blue clay of the valley, the soil here on the ridge was light glacial till, made lighter still by a century and a half of maple-leaf humus. We were down to the coffins by noon. To my enormous relief, both were still intact.

Jane fetched the oxen, and unhitched the stoneboat at the foot of her father's grave. With the iron bar she pried one end of Robert Hubbell's casket up at an angle. She then wedged an end of the borrowed bridge plank in under the raised casket. She wrapped the heavy rope we'd brought with us several times around the coffin and rapidly snubbed it off with a half-hitch. The other end of the rope she ran up over the top of the jutting plank and fastened to the pulling ring of the ox yoke.

Jane clicked to the oxen. "Softly, boys."

As the animals eased forward, Robert's coffin slid up the slanted plank. Like a well-balanced seesaw, the plank with the coffin on top of it tipped down onto the bed of the stoneboat. Then we repeated the process with Addie.

No doubt this would be a better story if I could report that, as the coffins rose out of the ground, the oxen shied, or a raven flapped past and croaked, or we felt a sudden chill in the air. No such thing happened, though. Nothing untoward at all happened. Jane clicked again to the oxen and drove them out of the Paupers' Field and across the road into the cemetery proper. Then she glanced up at the hazy sun. "I call this a fair morning's work, Robert. Time to take our nooning."

• ➷

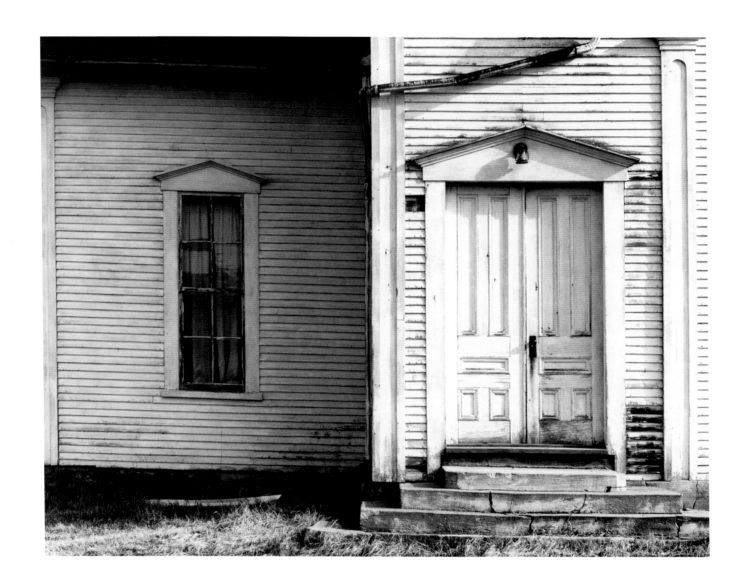

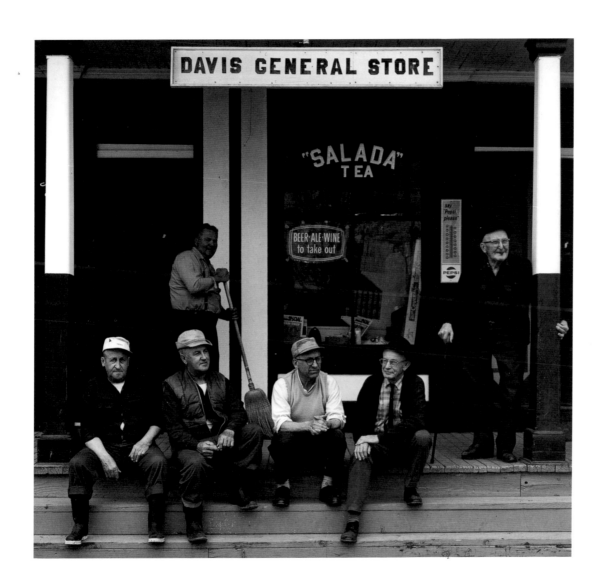

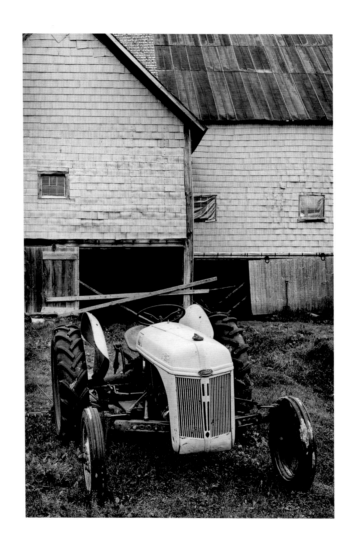

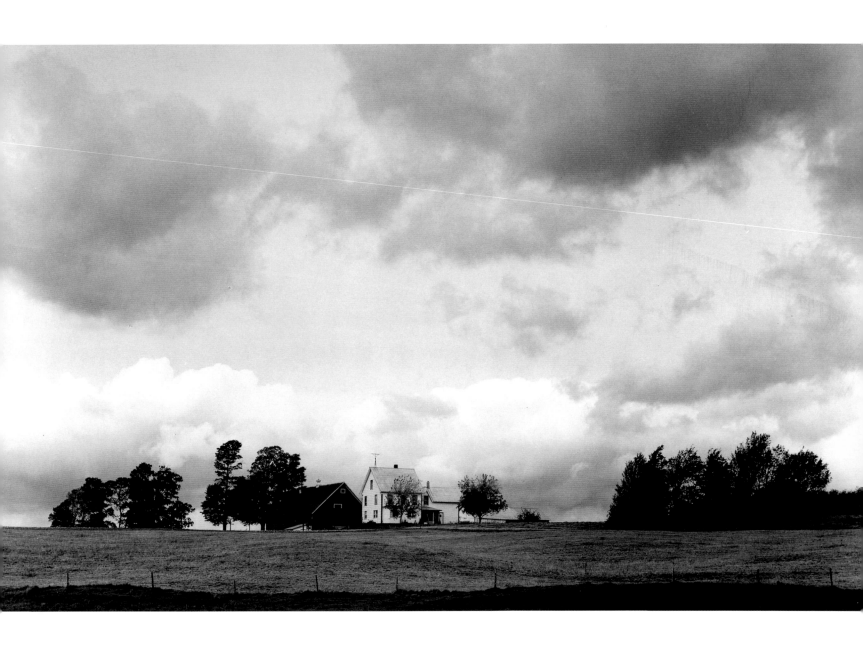

NOONING

E ATE ON THE GREENING GRASS UNDER THE MAPLE TREES, by the new graves. The two coffins sat nearby. As Jane unpacked the picnic hamper, I noticed that wild strawberries and small lavender cemetery violets had blossomed on the plots around us.

"Jane? Will these flowers die out when it turns cold again?"

"Why, no. They're great survivors, Rob. Like us Hubbells."

I was not sure what my great-aunt meant by calling the Hubbells survivors. Hadn't they all died out, and their farms and town along with them? Furthermore, it seemed strange to me that we could sit so comfortably beside the last earthly remains of Jane's parents and sprinkle salt on our hardboiled eggs and munch homemade baked bean sandwiches laced with maple sirup from the tall cemetery maples and drink cider from the snow apple trees. But we were hungry in the way people who have done hard work outdoors are hungry; and having soldiered through the morning, with Jane's help, I no longer saw the grave-moving as a ghoulish enterprise. Rather, as my aunt had said, we were taking care of family.

Jane unwrapped another sandwich and handed it to me, then carefully folded up the waxed paper to use again. "So, Rob. No doubt you will remember this day in later life. Picnicking with your great-aunt and hard taskmaster in Kingdom Mountain cemetery."

"You aren't a hard taskmaster," I said with my mouth full of bread and beans.

"Of course I am," Jane said. "I was an exacting overseer as a teacher and I am an exacting overseer as an aunt. You and I both know that."

Jane handed me one of her famous molasses cookies, as big around as a pie tin. "This puts me in mind of the day I got the receipt for these cookies, Rob. It was a very warm day, in the spring of the year, when I was keeping the Hubbellville school. I happened to cast a glance out the schoolhouse window and for a moment I thought that a caravan from 'The Arabian Nights' was winding down the valley from the north. It was the Ringling Brothers and Barnum & Bailey Circus Train, enroute from Montreal to Boston—one hundred cars painted bright yellow and blue and red! When it stopped to take on water at the Kingdom Mountain Station, I let the entire school out. They were doing some minor repair to the locomotive when we arrived, and it was such an unseasonably warm day that the circusmaster issued directions that the elephants be allowed to cool off in the river. As I live and die, Rob Hubbell, twenty elephants of all sizes were led out of the cars into the big pool below the trestle. The circusmaster was very accommodating to us. He pointed out Jumbo, the world's largest elephant. And he had one of the cooks give each of my pupils a huge molasses cookie. Those circus cookies were the best I ever ate. Before the train left I got the receipt."

Though I'd heard this story many times before, it touched me deeply today. "Aunt? I'm sorry that the interstate's coming. Coming to change everything, I mean."

"Change can often be change for the better, Rob. Even the Highroad will have its benefits. It's already helped to reunite the Hubbell family. It may help us in other ways as well."

"What ways?"

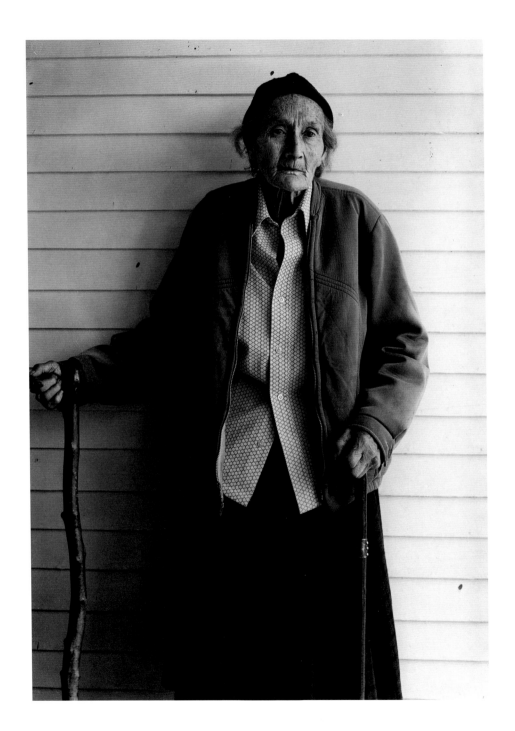

"Well, you might decide to venture out and attend college in Boston. The Highroad would carry you there faster and safer. And you could return to visit our mountain more frequently. Your folks and I should like that."

"Yes, but it'll bring tourists and summer people, too. Dad says the interstate'll bring summer people who'll build second homes on the mountain."

Jane looked down across the abandoned fields at the empty village of Hubbellville. "Second homes might be preferable to no homes. Any community might be better than no community."

I was not at all persuaded by this proposition. But Jane's eyes had the abstracted expression that sometimes came into them just before she had an experience of second sight.

"What do you see?" I said.

"I don't really see anything, Rob. It's more of an idea taking shape in my head. I just had the idea — only that — that you might be sitting here some fall day, years from now, eating a snow apple. And a car might come along the Highroad, and a girl might get out and walk up here for a picnic. A girl with hair as bright as the maple leaves. She would possibly be from Boston and she might — I say only that she might — be wearing a white summer dress. And perhaps you will give her an apple and tell her a story. And this girl with golden hair and a white summer dress will be the light of your life."

"What story would I tell her?" I said, pretending not to be interested. "How I moved some family graves with my great-aunt?"

Jane smiled. "A romantic young woman who would picnic here just because this is a beautiful spot to picnic would doubtless like to hear a love story, Rob. A love story different from any she'd ever heard before."

"I don't know any love stories," I said without enthusiasm.

"Hark, now," Jane said. "You're about to hear one."

A KINGDOM MOUNTAIN LOVE STORY

"WHEN MY YOUNGER BROTHER, ROBERT BURNS HUBBELL, was eighteen, he fell deeply in love with my best chum, Manon Thibeau. She was a beautiful young woman, Rob. And as much in love with Robert Burns Hubbell as he with her. But now enter my parents, who were appalled by the idea of a son of theirs — even a son named for a wild Scottish poet — courting a French Canadian girl. From the start, they were resolved to prevent the match at any cost."

"Wait! I thought your folks liked the Thibeaus. What about your father driving off the KKK that night?"

"Protecting a neighbor and his family from a cravenly mob was one thing. Countenancing a marriage between their son and a Catholic girl was an altogether different matter. What is more, Manon's parents felt exactly the same way about a daughter of theirs marrying a Protestant. Both sets of parents honestly believed that if Robert Burns Hubbell and Manon married outside their faith, they and their children and all their descendants to come would burn in Hell forever."

Jane looked at me. Then she said, "In the fall of 1918—the fall of the influenza epidemic—Manon vanished."

"Vanished? You mean she disappeared? How could she disappear?"

Jane did not reply immediately, but sat looking silently down the mountainside toward the cedar bog far below. Then she said, "Manon was the girl I told you about who disappeared in the bog. The Thibeaus never placed a marker for her in the cemetery across the road because they kept hoping she'd show up. But she never did."

After a shocked pause I said, "That's a sad story. I like the circus story better."

"It's not over yet, Rob. Just as the Thibeaus lost a daughter, my folks lost a son. After Manon disappeared, Robert Burns Hubbell ran away out west and didn't write home for six years. All that time he was dead to us. Even after he finally contacted us, he never came home. And in their despair over losing a son, my folks turned against the very doctrines they had cleaved to when Robert Burns Hubbell and Manon wished to marry. They withdrew from the church, turned away from the religion of their ancestors altogether, and even insisted on being buried outside the cemetery, in the Paupers' Field, with the French Canadians and outcasts and unknowns."

Jane paused. Then she said in her strong, assured voice, "But times change, Rob. And you and I have a role in all this as well. Our role is to rectify what we can by reuniting family and neighbors. And in matters that we can't rectify, at least to bear witness to all that has happened —and to do so without judgment."

·➴

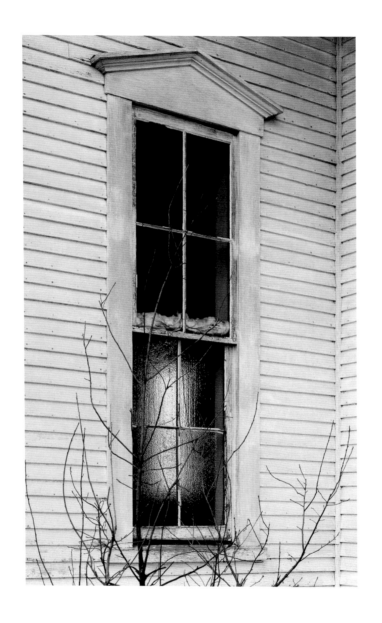

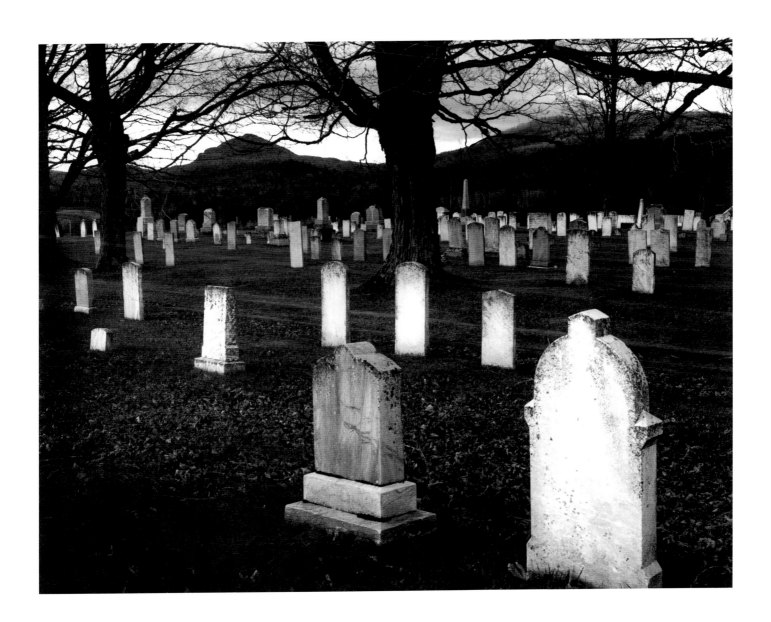

EASTER WATER

JUST OUTSIDE THE CEMETERY GATE AN ANCIENT IRON PUMP sat on a granite millstone. The pipe from the pump extended through the hole in the middle of the stone. It was connected to a well deep under the ground. This well was believed to be an underground aquifer of glacial melt-water, ten thousand years old. The water was the coldest and purest in all Kingdom County. It was called Easter Water because for more than one hundred years people from Hubbellville and the surrounding farms had gathered here on Easter morning, often in an April snowstorm, to pump water for washing and drinking. It was thought that the Easter Water washed away sins, assuaged guilty consciences, and healed grudges between family members and neighbors. How this tradition started no one knew. But Presbyterians and French Canadians alike, and even a few non-believers, had all made their pilgrimage here on Easter Sunday to pump the sacred water from deep in the mountain.

Jane filled an old blue flower vase from an ancestor's grave with brook water for me to prime the pump. The pressure pulled back on the handle like a big trout, and I loved thinking that the icy water that gushed out of the rusty metal spout might have come straight from a glacier. We filled the vase and returned to the two coffins, which we slid, one at a time, down the plank into their new graves. Jane picked a few strawberry blossoms and violets and dropped them onto the coffins. She dipped her fingers into the brimming vase and sprinkled water over the coffins and the flowers. A mourning cloak butterfly, which like the flowers had been fooled into emerging by false spring, landed on one of the coffins, and sipped at a droplet of Easter Water. It was so recently hatched that its blue and yellow wing bands still glistened. "Go back to sleep," Jane said, shooing the butterfly away with her shovel handle.

"Go back to sleep," she said again as we began to fill in the graves. This time I did not think she was talking to the butterfly.

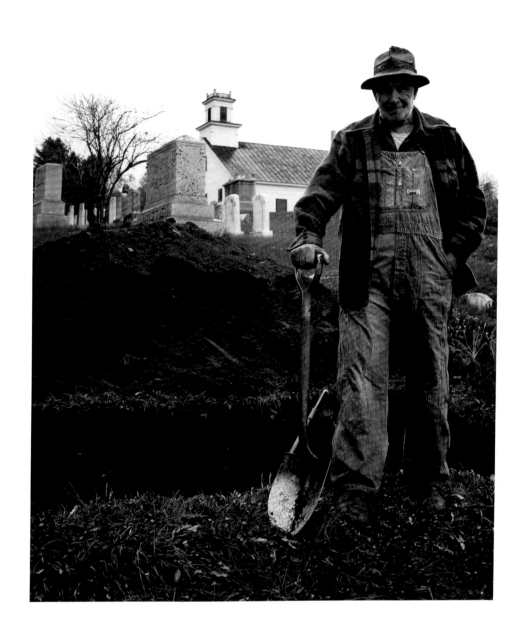

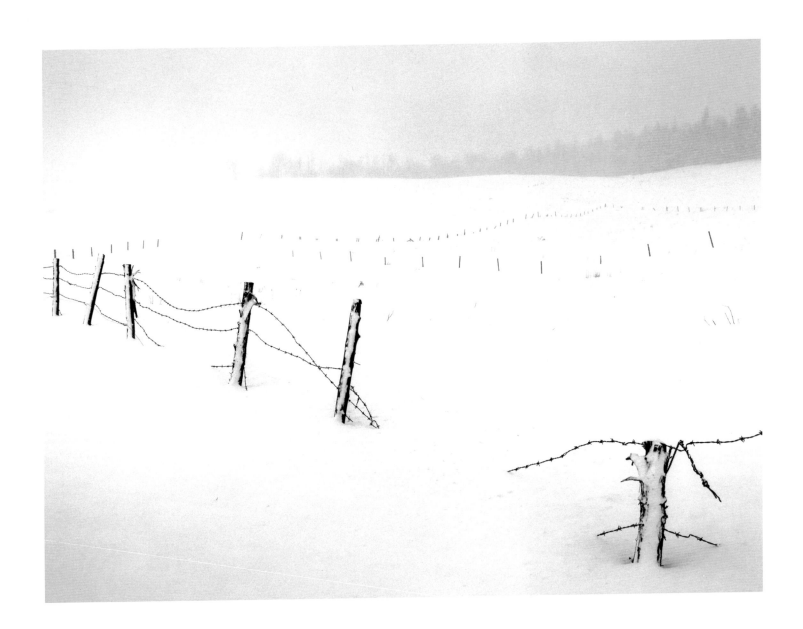

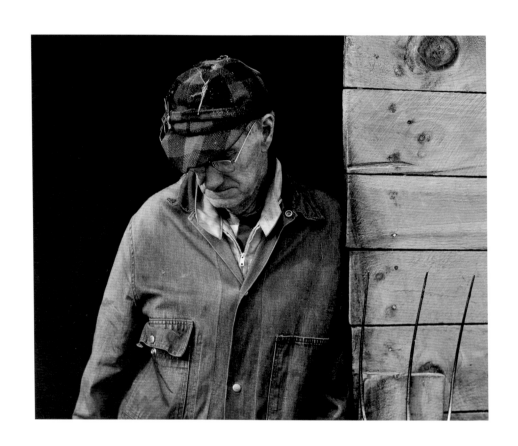

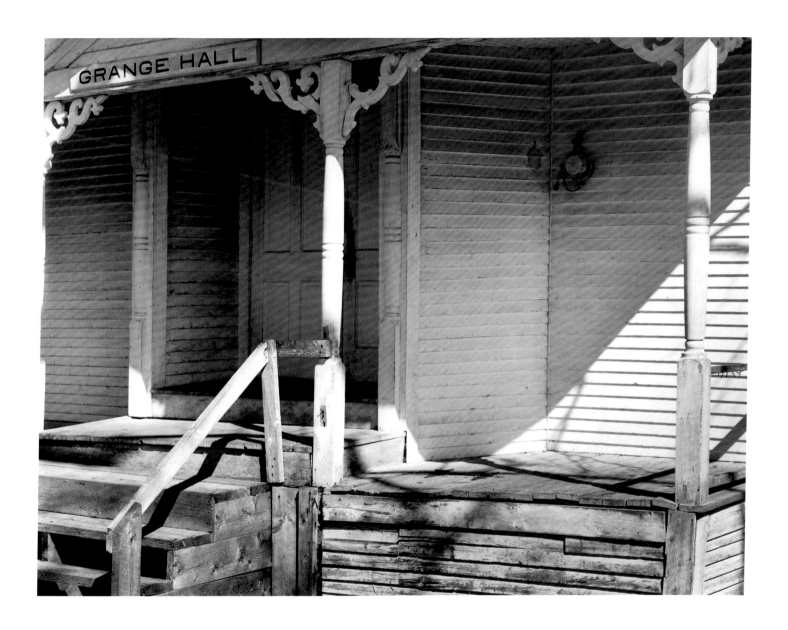

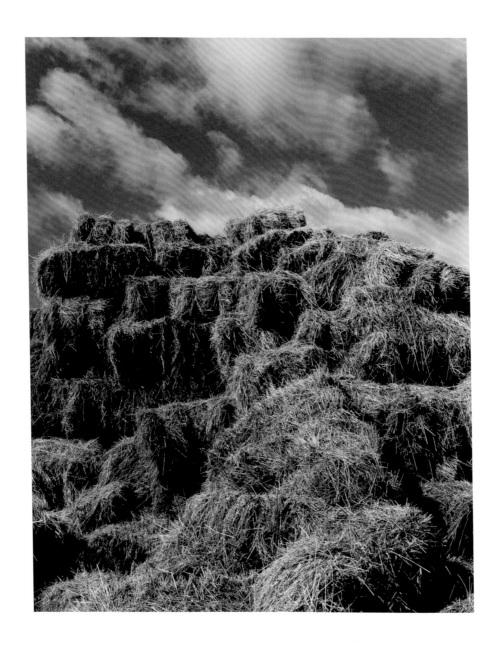

LEAVING NO JOB UNFINISHED

IT WAS NOTICEABLY COLDER WHEN WE RETURNED TO THE Paupers' Field with the oxen to move the granite markers of my great-grandparents. They were not large, and it was not hard to dig them out, tip them onto the stoneboat, and move them across the Post Road to the cemetery.

Then we went back to fill in the empty graves in the Paupers' Field, Jane taking care to shut and fasten the cemetery gate behind us. There were no longer any cattle or horses or sheep on this part of the mountain to wander into the cemetery. Closing gates was simply what we country people did. It went beyond habit.

The wind was gusting out of the north now, sweeping down from the Canadian mountains and blasting Cemetery Ridge as it had since long before there were any people here, alive or dead. As we threw the dirt back into the holes, I could feel blisters beginning to form on my hands.

"The state would do this," I said, though I did not really see why anyone had to do it. By spring—true spring—the Paupers' Field would be gone, bulldozed away for the interstate.

"No doubt," Jane said, continuing to dig. "But we'll not leave this job unfinished, Rob."

When we were through, the sun had dropped below the mountains. "A harsh and forlorn place, Rob," my aunt said, not without satisfaction.

"I'd have liked to see it when it was all cleared to fields and pasture."

"Maybe you will."

I looked at her but all she said was, "Let's head home."

We started down the mountainside on the Canada Post Road, the oxen moving faster to reach the barn by nightfall. Hubbellville looked emptier than ever, the bog darker and more forbidding. When we passed the cornfield the snow geese lifted up in a great white cloud against the darkening sky, circled the mountaintop once, and formed up in a V to head south on the strong north wind. I knew we had seen the last of them until spring.

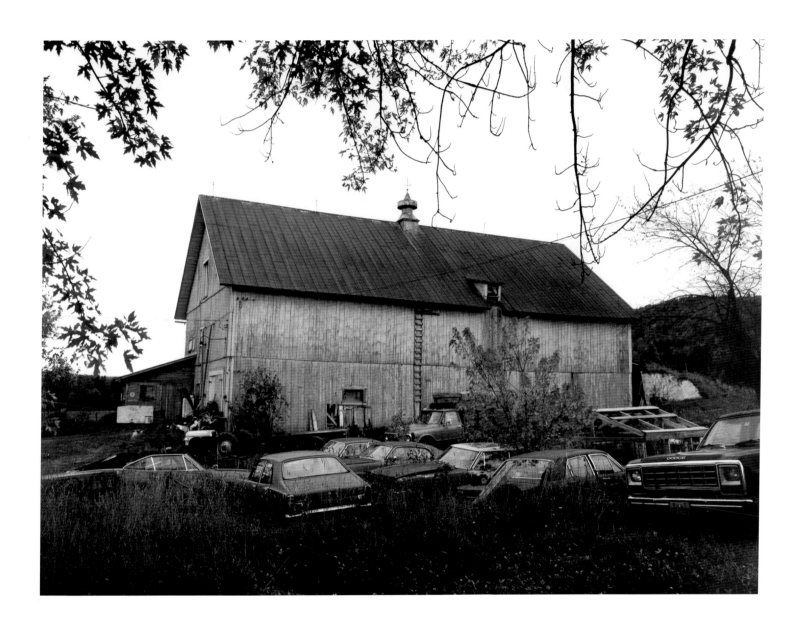

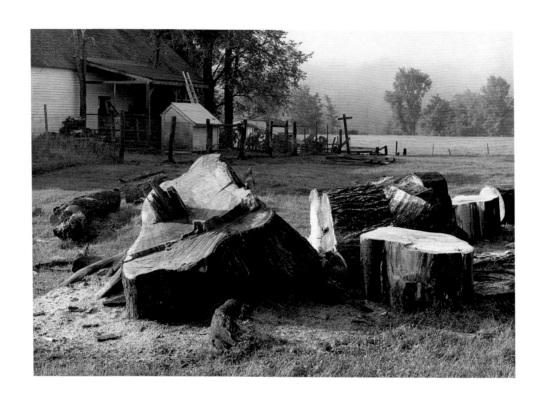

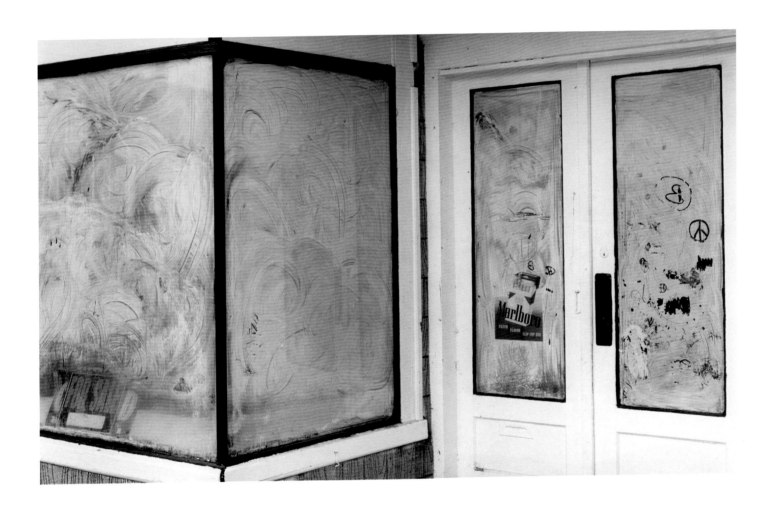

GHOSTS

BACK AT THE HOME PLACE I FED AND WATERED THE OXEN, milked the single cow Jane now kept, fed the pigs and chickens, and picked up the eggs while Jane built a fire in the kitchen range and made supper. When I came out of the barn it was full dark. I could see the light from my parents' kitchen window down the mountain. They would see Jane's light and know I was staying on at the Home Place for supper.

We ate on the kitchen table with the red-checked oilcloth, a plain country supper of homemade sausage, toasted homemade bread, fried potatoes, and apple pie. Afterward Jane surprised me by asking me to make a fire in the parlor stove while she did the dishes. Usually if we wanted to visit after supper, we sat in the kitchen, like most farm families of that era. Jane used the parlor mainly for special company and for Thanksgiving and Christmas. It smelled of musty books and ancient furniture. Two deer heads and a big brook trout from the cedar bog were mounted on the wall—trophies taken by Robert Burns Hubbell before he went west. The Round Oak stove was

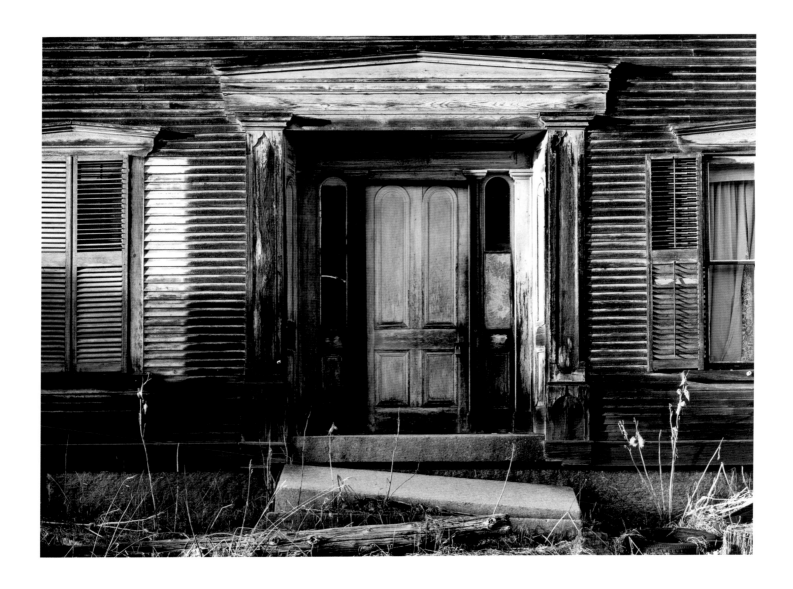

decorated with chrome fittings that Jane kept carefully polished. On the arms and backs of the stuffed horsehair sofa and matching love seat were white antimacassars. Two glass-fronted bookcases contained complete sets of Shakespeare, Dickens, the Harvard Classics and the 1910 Eleventh Edition of the Encyclopedia Britannica.

From the top of one of the bookcases Jane took down the cardboard box containing her stereopticon. The stereopticon was a hand-held forerunner of a slide viewer. It was a wooden device about a foot long. At the front was a binocular eyepiece with a thick lense, behind which a rectangular pasteboard card mounted with two identical photographs was placed. When viewed through the lense, the twin photographs formed a single picture in three dimensions.

Jane fetched another cardboard box. From it she selected a slide, which she inserted in a wire-frame holder on the far side of the stereopticon lense. To focus the twin photographs, you moved the frame like a trombone slide. As a small boy, I had loved repairing to the parlor with Jane and my folks after a holiday meal and viewing slides of the Grand Canyon, the Eiffel Tower, Niagara Falls and other exotic places. Tonight, I could scarcely hold up my head. Viewing an outdated travelogue was worse than not being allowed to hunt the snow geese! But when I sat down beside Jane and slid the photograph into view, what came into focus was the Home Place. In front, by the gate, was a box-shaped wagon drawn by a white horse wearing a straw hat. On the side of the cart were the words "Pamphille Thibeau Peddler." Beside the horse stood a smiling man, with a straw hat like the horse's. Viewed through the stereopticon, Pamphille Thibeau looked strikingly life-like. Beyond him the Home Place gleamed with fresh paint. Over the gate was a wooden trellis covered with blossoming roses. Another rose bush grew by the granite stoop in front of the porch.

Jane handed me another slide. It was a formal tableau of people in old-fashioned suits and long dresses. They were posing in chairs in the lawn in front of the Home Place. Behind them children of various ages posed on the porch steps.

"The man with the beard sitting in the Boston rocker beside the frail-looking woman in an identical rocker is my father," Jane said.

My great-grandfather and namesake, Robert Hubbell, looked gravely out of the picture, as if he were viewing me, rather than vice versa, and I did not quite measure up. I had no trouble imagining this stern churchman and patriarch facing down the sheeted KKK nightriders. Or forbidding Robert Burns Hubbell to marry Pamphille Thibeau's daughter, Manon.

"Where are you, Aunt? I don't see you in the picture."

"For pity's sake, Robert, I'm taking the picture. For my fifteenth birthday, my folks bought me a little box camera — from Pamphille. I took all these pictures with it."

For the next hour, while the wind rose and the stove ticked, Jane handed me one slide after another from the pictures she had taken as a girl and young woman.

"County Champions," she said. Into view came a dozen schoolboy ballplayers. They were wearing baggy homemade uniform pants and shirts and homemade caps with rounded bills that made their faces look like the faces of grown men. The County Champions were sitting on the railing of the Hubbellville school porch. Some wore old-fashioned baseball gloves, with pockets thin as pancakes and fingers thick as sausages.

"Circus Train, 1931," Jane said. Here, in front of my eyes, was the Ringling Brothers and Barnum & Bailey train, sitting on the siding by the water tower near the trestle.

"Jumbo, World's Largest Elephant." The World's Largest Elephant stood knee-deep in the big pool below the trestle, spraying his back with cool river water.

Jane handed me a slide of the Hubbellville church. The toppled steeple was miraculously reattached. On the lawn in front people were eating box suppers on trestle tables. "Church Supper."

Next came a photograph of the Kingdom River in the spring, packed with logs from bank to bank. Downriver in a bend more logs were flying high into the air. "Dynamiting

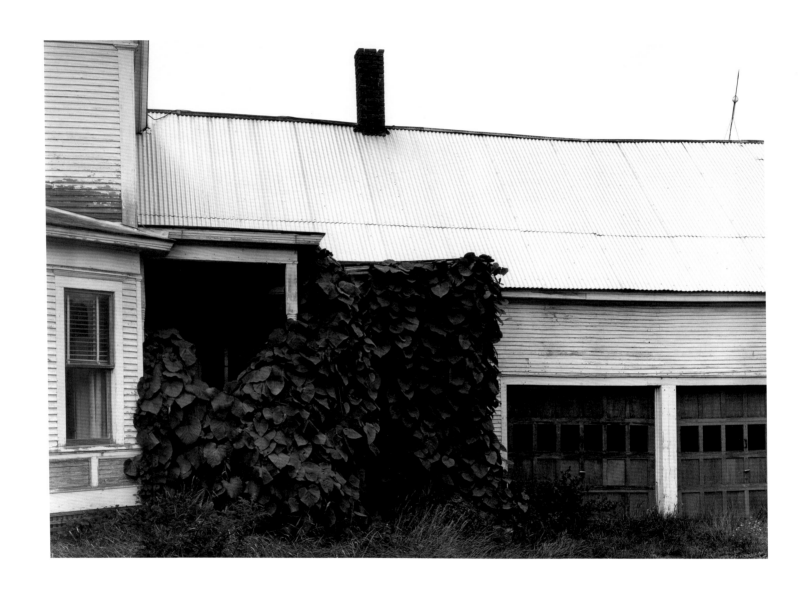

92

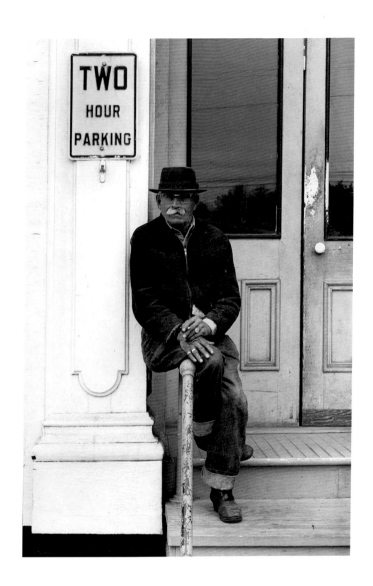

the Jam," Jane said. Men in calked boots and checked shirts stood on the bank, holding long, iron-shod pikes. I wondered if one of them was Died Fightin.

"Blueberrying, 1919" showed a young man and a young woman kneeling in bushes up to their waists. The girl had long black hair and a heart-shaped face below a wide-brimmed sunhat. She was wearing a white blouse with a high lace collar. I knew without asking that this was a picture of Robert Burns Hubbell and Manon Thibeau.

Next came two photographs of the west side of Kingdom Mountain, cleared to fields, where originally there had been only woods, and woods were now fast encroaching once again. Jane showed me farmers sitting on chopping blocks with dogs at their feet, hunters standing beside buck deer hanging from dooryard maples, logging horses skidding gigantic tree trunks through snowy evergreen woods, men in suspenders and felt boots yarning around the stove in the Hubbellville store, looking as deliberate as Supreme Court justices.

Another photograph had been taken on a stormy winter day. In it people in sheep coats and fur hats were lined up in front of the post office and store. The queue of people stretched along the porch past the window with the "Salada Tea" sign and down the steps and out into the snowfilled street. "Waiting for David Copperfield," Jane said.

The last slide showed the people of Kingdom Mountain marching in a parade through Hubbellville, led by a three-piece brass band. Jane told me that they were celebrating the 1918 Armistice, never dreaming that in less than two weeks the town would be struck by the epidemic that would kill one of every two men, women, and children in the photograph. Through some trick of light or exposure, the eyes of the marchers looked white and spectral. "Ghosts," Jane said. "I call this Ghosts."

• ◞

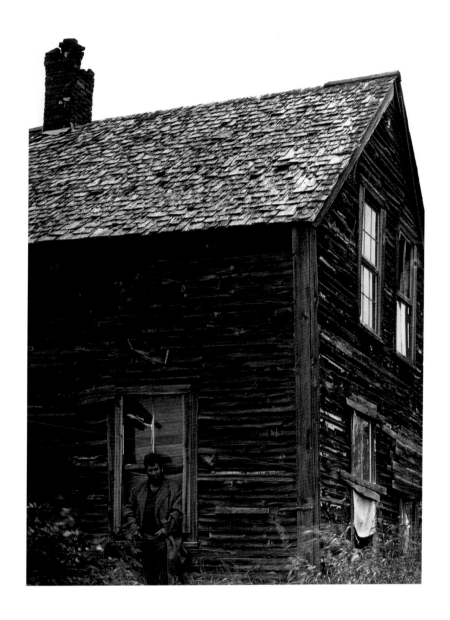

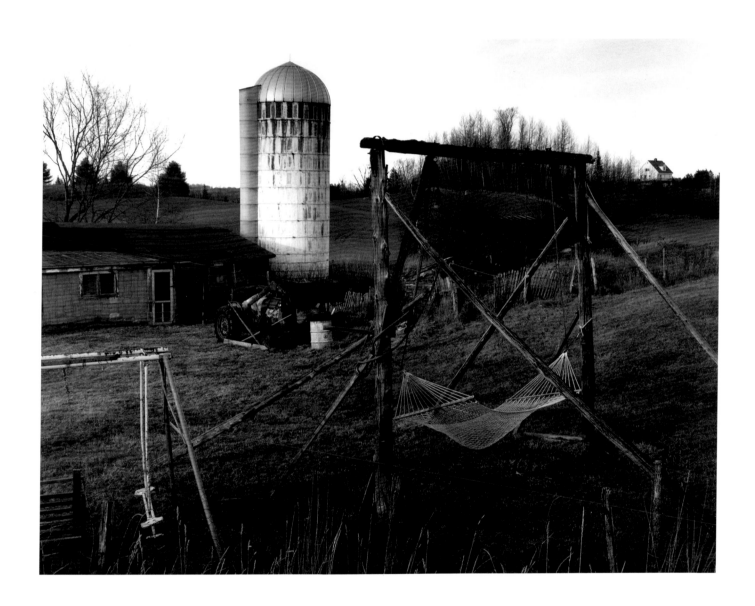

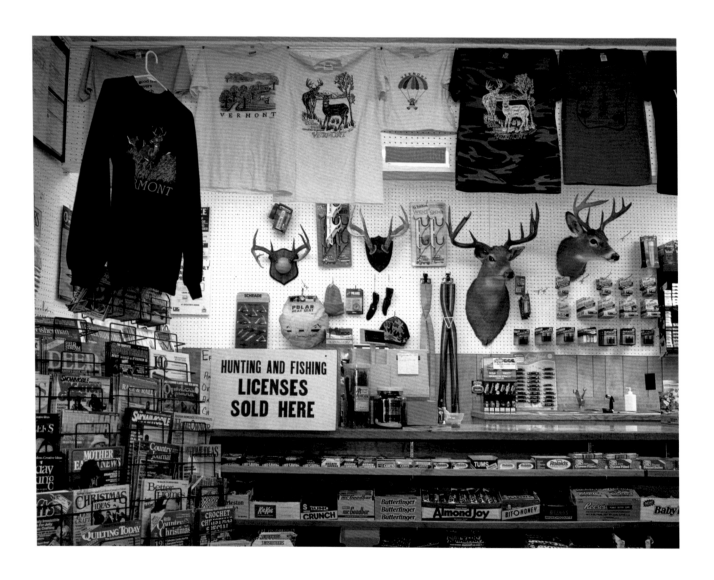

THE LEGACY

I STOOD UP, NOTICING FOR THE FIRST TIME THAT I WAS taller than the Round Oak parlor stove, though not yet as tall as my great-aunt.

"Thank you, Rob. For your help today."

I shrugged and started to leave the parlor. But Jane held out the boxes with the stereopticon and slides. "These are for you."

"I don't want a present. I was glad to help."

My great-aunt smiled. She knew, as I knew, that the exact opposite was true. I had not been glad to help—not at the time. And I very much wanted the photographs Jane had taken and the stories that they told.

She tucked the boxes under my arm. Then she smiled again. "Show them to the girl in the white summer dress."

I started out the door. But since I had worn no coat that morning and it was now sharply colder, Jane called me back and handed me her red wool hunting jacket, telling me I could return it when I came up for chores in the morning.

Jane stood in the doorway and saw me down off the porch. In her dooryard it was snowing lightly. False spring was over.

"Rob?" Jane called. "The photographs aren't a present. They're a legacy."

Then she stepped back inside and closed the door while I headed down the mountain toward the light in our kitchen window. Overhead the moon was a pale disk through the lightly falling snow.

Trotting down the lane toward our farmhouse that night, I had no idea whom the Highroad might bring to Kingdom Mountain, nor could I guess where it might take me. The wind gusted at my back, swirling the snow around my feet. High on the ridge top, in the Kingdom Mountain cemetery, it was doubtlessly snowing harder, beginning to cover the flowers of false spring, the granite and cedar markers, the newly dug graves. But there were no ghosts there tonight. Only stories, some of which might remain mysteries for all time to come.

·ᴗ

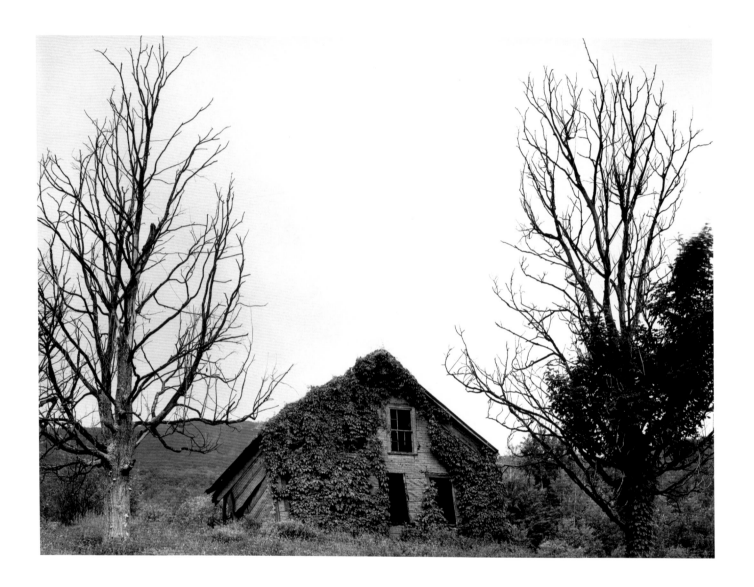

SECOND SIGHT

MY WIFE, AS IT TURNED OUT, DID NOT COME TO KINGDOM Mountain on Jane's Highroad. She grew up in the village of Kingdom Common, the fifth daughter of a family she jokingly calls as French Canadian as yellow pea soup. Nor does she have light hair, though our daughter Jane does. The fall Jane turned fifteen—just my age during that long-ago year the interstate came to northern Vermont—Jane and her mother and I went to the Kingdom Mountain cemetery together to visit my great-aunt's grave. Our daughter happened to be wearing a white dress, sprinkled with tiny lavender violets like the wild violets her great-great-aunt and I found there many decades ago, on the day in false spring when we moved the family graves.

Today was a normal fall day. The sugar maples through the middle of the cemetery were the same polished gold as our daughter's hair, and the snow geese were going over north to south, as geese should in the fall. As I told Jane the Kingdom Mountain love story, she and her mother and

I looked down at the half-dozen second homes that had been built on the mountain recently, including ours. Hubbellville was gone, and the Paupers' Field as well. No one lived year-round here now; and nowhere on the mountain were we out of earshot of the steady hum of the long-distance trucks on the interstate.

"There's her stone," I said to Jane. "'Jane Hubbell, 1887–1968. Daughter Teacher Sister Friend.'"

"I like that," our daughter said, smiling.

"You'd have liked her," I said. "She'd have liked you, too."

"I know she would have," Jane said. "And I knew you were going to say that."

"How did you know?" her mother said.

"I just did," Jane said with all of the serene certainty of her namesake. "I think it runs in the family."

·⌒

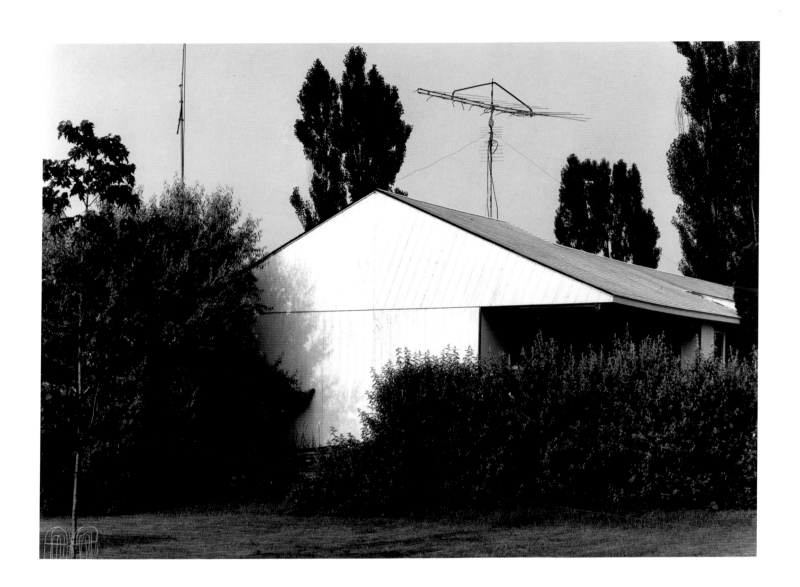

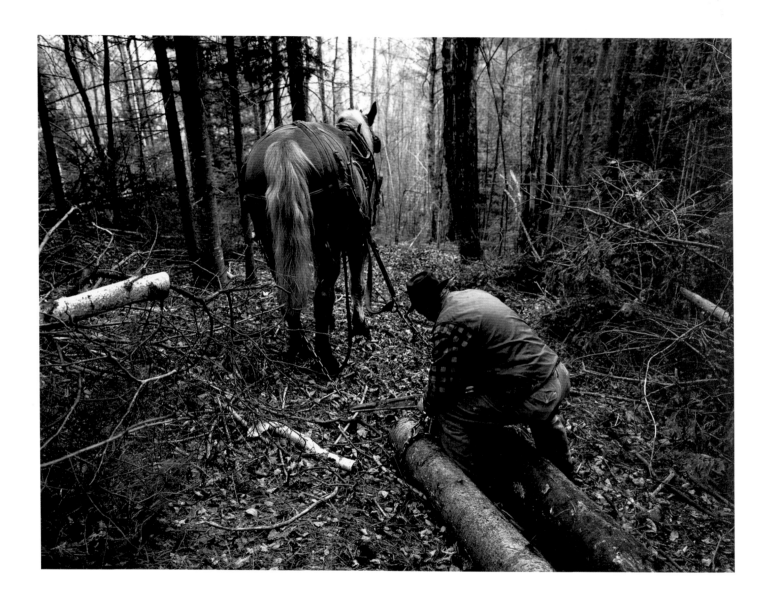

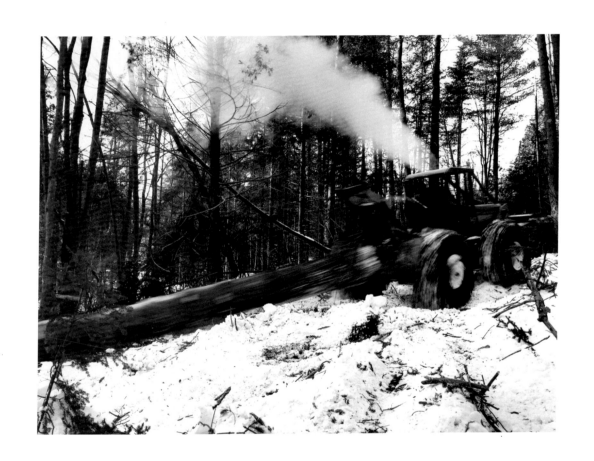

ACKNOWLEDGEMENTS

Many people in the Northeast Kingdom repeatedly opened their homes to me and took time from their work when, for instance, they were hand-scything a field, logging with horses, or actually digging a grave. I was often served meals of epic proportions if I happened by some of the farm families around dinnertime, a habit of mine that never seemed to wear out my welcome. The photographs in this book are a mere trace of those memorable encounters. It is to these people, so grounded in the land, rural traditions, community and place to whom I dedicate this book: Mildred and Harold McCoy, Leslie Dewing, Henry Vinton, Marjorie Stoddard, Maude Cross, Joe Mandigo, Edna and Clayton Hopkins, Ernest and Evelyn Earle, Winnie Doncaster, Malcolm Davis, Joe and Charlie Hebert, Lloyd Hackett, Duncan Chaffee, Foster Babcock, Miss Jean Simpson, Burns Goss, Elmer and Gladys Burrington, Lenny Switser, Raleigh True and the many others whose portraits did not make the final edit for this book.

These photographs began as a photo-documentary in 1970, but it was not until the 1980's that this project evolved into a book idea. Friends such as Phil Grime, fellow native of the Northeast Kingdom, offered insights into my photographs and how I might re-interpret them in the context of agrarian culture and change. Encouragement by the late photographers Lotte Jacobi, who recommended that I concentrate on the portraits, and Ralph Steiner, who preferred my architectural forms and landscape, fueled my passion for all three genres. Those who tolerated my long absences—the many hours spent in the field photographing and the late night printing sessions in the Shelburne Museum darkroom that had been kindly offered for my use —always supported my work, too. Many thanks to Andrea, to my daughter Jennifer, and to my mother Harriet who enthusiastically worked with and introduced me to some of the people in these photographs.

The photography and development of this book were funded in part by the Vermont Council on the Arts and the Vermont Community Foundation. I would also like to thank Howard Frank Mosher and the Vermont Folklife Center for their continued support of my work and their vision to record honestly the essence of rural life in their work.

John M. Miller